Art Classics

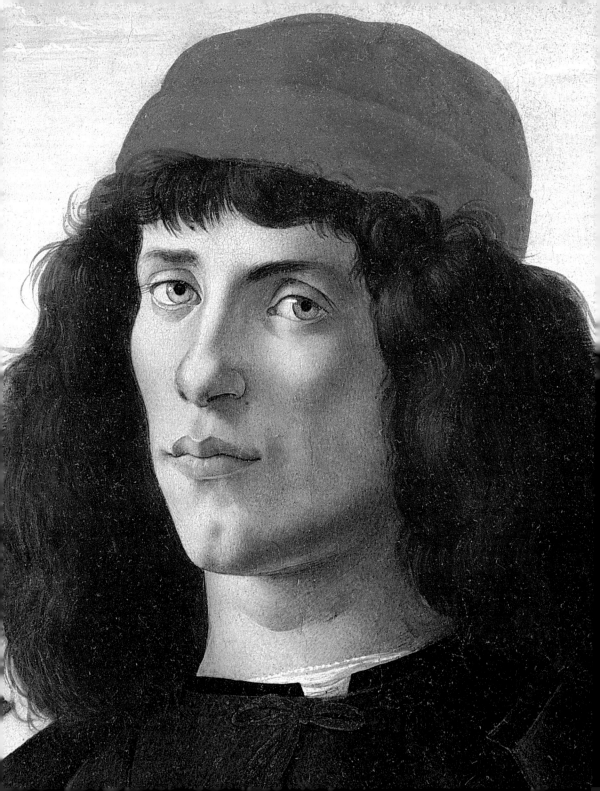

Art Classics

BOTTICELLI

Preface by Carlo Bo

RIZZOLI
NEW YORK

ART CLASSICS

BOTTICELLI

First published in the United States
of America in 2005 by
Rizzoli International Publications, Inc.
300 Park Avenue South
New York, NY 10010
www.rizzoliusa.com

Originally published in Italian by
Rizzoli Libri Illustrati
© 2004 RCS Libri Spa, Milano
All rights reserved
www.rcslibri.it
First edition 2003
Rizzoli \ Skira - Corriere della Sera

2005 2006 2007 2008 2009 /
10 9 8 7 6 5 4 3 2 1

Printed in China

ISBN: 0-8478-2676-7

Library of Congress Control
Number: 2004099912

Director of the series
Eileen Romano

Design
Marcello Francone

Editor (English edition)
Julie Di Filippo

Translation
Anne Ellis Ruzzante
(Buysschaert&Malerba)

Editing and layout
Buysschaert&Malerba, Milan

Cover
Birth of Venus
(detail), 1484
Florence, Galleria degli Uffizi

Frontispiece
*Portrait of a Man with the Medal
of Cosimo the Elder*
1475
Florence, Galleria degli Uffizi

The publication of works owned by
the Soprintendenze has been made
possible by the Ministry for Cultural
Goods and Activities.

© Archivio Scala, Firenze

Contents

Life beyond Seeing
Carlo Bo

When we consider the painter Botticelli we find ourselves in a privileged position, as occurs each time that debate and interpretation pile up around an artist's corpus, and which, in this artist's case, have done so for centuries. This free acceptance or, rather, this stratification of cultural movements, is a sign of artistic distinction: acceptance and stratification not only register the richness of Botticelli's artistic invention, but also the continuity of the cultural debate. In a certain sense, an artist foresees a long way in advance that which appears to the eyes of observers, and he makes use of tones and solutions in his work that only after many years acquire their true value.

By this I mean that our manner of looking at Botticelli's work is completely different from that of his contemporaries, and is probably different from the assessment made by the very greatest of them (by this, read Leonardo) as we—sometimes consciously but more often unconsciously—add something that belongs to the sum of the cultural experiences that have accumulated over his model of invention. Naturally, in processes of this kind there is a great deal of personal discretion involved, but it is justified discretion, otherwise there would be no sense of history and it would be impossible to appreciate the work we are looking at or that of earlier artists.

Life of Saint Zanobius, Last Miracle and Death (detail), 1500–1505 Dresden, Gemäldegalerie Alte Meister

Let Botticelli be an example, in whom two registers coexist that have nothing in common: the arrangement of the fixed elements in his paintings and the intimate, profoundly sentimental condition of his figures. In this sense, the theater or spectacle of the life that he offers us is al-

ways twofold: on the one hand there is respect for what we might call the architectural construction of his themes, and on the other there is a peremptory invitation to enter the romance alluded to by his figures. The painter says everything, or at least seems to, and to indicate what he wants to say in his painting but, if we look closer, there is—evident but also hidden—another scene that only a modern mind can succeed in bringing to life. The regularity of the setting and the precision of the reality he depicts are evident, but it would be foolish to attach a meaning to the legends he portrays, which only superficially reflect the stories themselves or the text of his compositions. And because the artist exerts a severe demand on himself, the observer is immediately led to notice the uncertainty, doubt and worry on the faces of his men and women. On so many occasions we have made a pure, simple and linear translation of the world of his time, almost as though it were a question of the canvas being filled with fixed examples (and then we are prompted to attribute a surprising, modern value to his figures), whereas we have not always attempted to look beneath the veil of melancholy with which the painter imbues his figures. Today it is this veil that provides us with the means to get closer to the art of Botticelli and which makes his art one of the interpreters of the human spirit in its absolute sense. When the artist reached his full maturity, he was able to condense into a single figure both an architectural composition and the expression of sentiment.

It may be worth the trouble to ask ourselves what it was that prompted this rare dual approach within the rigidity imposed by composition. And this is where we touch upon the first aspect or outcome of Botticelli's cultural condition. What little we know of his life and what we are able to deduce from knowledge of his world are certainly not enough to resolve the problem, at least in the sense of establishing, point by point, the stages of his development. That does not mean that

the existence of this fact is sufficient to understand that the artist's be-havior confronted by the reality of his environment was never natural and that reality was imperceptibly altered by the added interpretation of cultural data. In choosing a particular solution for a painting, there must have been a constant relationship between what Botticelli saw and what he wanted to see from a much wider point of view, beyond that of the dictates of his own taste. It is sufficient to consider the charge his figures contain, and the inner burden their faces represent, to perceive a dialogue or a reasoning that supplies an interpretation, a meditation and the perennial pursuit of a higher truth.

T he observer cannot but be attracted by the open or closed ques-tions that we see on the faces of Botticelli's figures: his work de-mands this constant attention and it seems difficult to be able to ignore it. At most we must ask ourselves how we must frame our re-sponse, and to what point we must establish a contact to understand the nature of the secrets in question and to see if we are able to enter a relationship that is very different to one of simple enjoyment or the simple act of acceptance. What was termed "romance" above arises from just this situation, one which merges the artist's personal motives (of which we know nothing) with higher, more general ones linked to the humanity of the figures in the painting. It is not wrong to speak of the apparent immobility of these figures or, paradoxically, of an im-mobility animated on another level. Where do these characters come from? For many there is a precise anagraphic relationship, but one that is of no use because the gap between the part left in question and the margin of the other apparition is vast, to the extent that, at a distance of several centuries, we are unable to bridge it.

Furthermore, with regard the history of the artist himself, it should immediately be added that much of this secret or unspoken discourse,

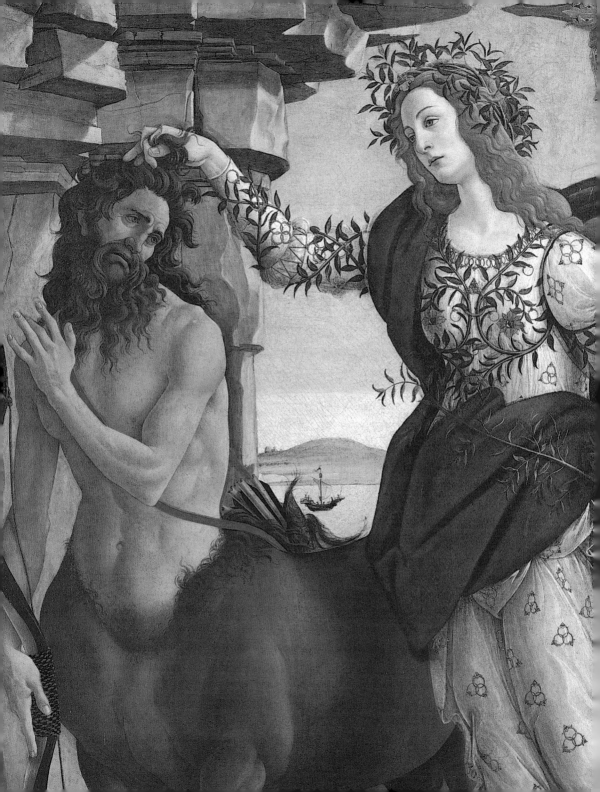

or a discourse spoken in another language, is borne by "Botticelli, the man of culture". He was one of the first to sense the limit of reality, to disrupt fixed interpretations and to place in doubt the validity of hermetically sealed art. Yet, at first glance, he also seems rigid in this sense, to the point of seeming cold and frightened to go beyond the lines of the exterior composition. But it is within these impressions that we become aware of the chance to test the apparent order. And then, the surprise that resolves how we read the painter's work is quickly forthcoming: the rigidity of the interpretation conceals a dramatic and very different understanding that is almost irreconcilable with the assumptions of the theme. I would say that it is in this long battle with himself that the greatness of Botticelli should be sought. It is a war of which precious documents remain, not simply with regard to details but also on the subject of the entire construction of his work. Without that inner struggle, he would have not undergone a personal religious transformation nor decanted those themes of life and nature into his paintings that led to the expression of a different psychological dimension. It is clear that in these cases neither the will nor the need for adjustment is enough. Art cannot stand these conditionings unless artists are prepared to distort their work.

Try to study the passage from free invention, within the framework of nature, to the play of compositions and the study of completely different themes, and you will see that this transition was possible because first there had been an overturning of those same natural motives from the inside. On his early faces one does not see even an iota of joy; his characters appear frozen, painfully surprised in the face of a secret of which the observer is unaware. If there had been greater tranquillity in Botticelli, certain works such as the *Allegory of Spring* would have the violence and power of an explosion. On the contrary, everything is resolved on another level and the movement of the painting is suddenly

halted, blocked, as though it had been the victim of another condition. His characters are serious and betray a truth that no nature shall ever be able to bear. In the act of illustration, therefore, a basic doubt has remained on the faces and in the gestures of his figures, and even in that slight degree of stylization that disturbs us the first time we see them. Evidently Botticelli did not have the courage to shift the axis of his study and bring to the surface his second vision, his real interpretation of the world that the condition and the law of culture had suggested to him. It is in these rifts at the first level of his discourse that a modern observer is able to gain an entry to, and participate in, an analysis that is generally bypassed. If the condition of culture really means the ability to transform elements of reality, Botticelli drew the greatest part of his power from the new current of the art of his time. The apparent immobility of his figures ends up giving a contrasting emphasis to the elements in his images, and, in the effort to contain and respect the rules of his apparent constructions, we see the dramatic violence of his uncertainty. It often seems that his figures cannot speak, and this is true, but this barrier is not created by an excess of the artist's control in the sense of perfection, but rather by the knowledge of the existence of another language, the closed language of those who are dominated by a passion of which others are unaware, or for which no translation is authorized. But what the artist is afraid of opening remains at the disposition of the observer today who is primarily fascinated by the absence and apparent emptiness of the discourse; he cannot but feel the importance of awareness, which is the essence on which the artist's interpretation is based.

The stages are these: at first, reality was insufficient for Botticelli, for which it no longer seemed possible to take to the extremes his idea of balance (the perfection of the composition does not signify balance, rather, in this case it denotes a large degree of uncertainty); later, once

Saint Augustine (detail), 1480 Florence, Church of the Ognissanti

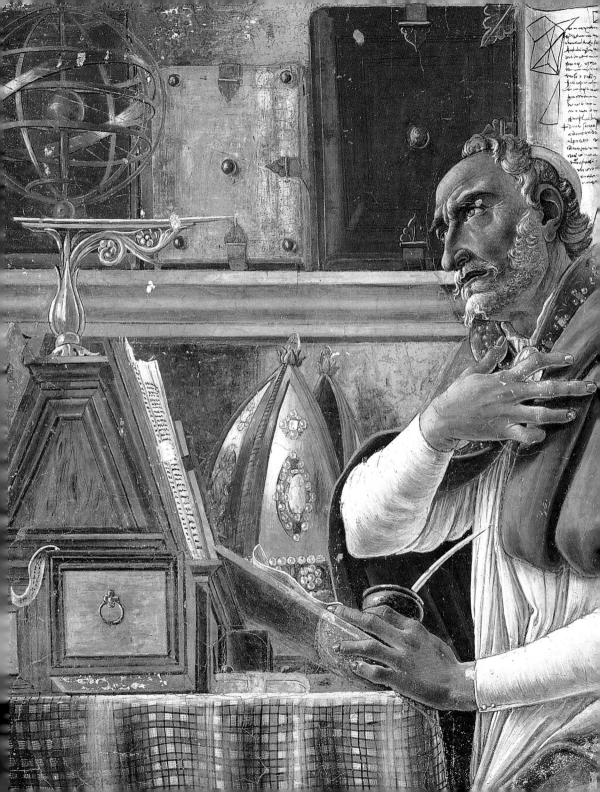

this door onto the unknown was half-open, cultural influences made themselves felt (ranging from his associations in Florence to the idea of annotating Dante through images); and finally, the artist soothed his anxiety with religious invention. His religious subjects are disturbing, and even more so the simplicity with which he eventually treated them. This is partly because, within the same religious book, there are figures of saints that convey the same sense of drama that we find in his lay figures; the artist created this dramatic impression using a clear-cut and decisive solution within the scope of the violence that the damned described in Dante's work were doomed to suffer.

What was the cornerstone on which the artist founded his transformation? It must have cost him dearly, as happens every time that an artist tries to overcome stimuli and cultural suggestions. The answer is this: between the two stages of his art the fifteenth-century Italian reformer Savonarola rose to power in Florence. It matters little to us that there is little evidence of Savonarola's influence. In order to understand Savonarola's presence and importance, it is sufficient to think of Botticelli's early period and his development. He probably considered Savonarola's position to be a clear, absolute and flat negation of everything that he had learned from books and debates with his friends, and which had constituted the basis of his doubt.

Savonarola must have appeared to Botticelli like a spirit able to resolve his uncertainties, and the only intelligence able to offer him the key to the mystery that darkened the faces of his figures. At the bottom of that darkness, of that painful and extenuating form of "absence" that he had felt arise in the heart of the world, Savonarola's discourse gave him reason to hope for salvation, a reason on which he could base the task of dissolving the mists and anxieties of his cultural disquiet. The language used by the friar—so different to that of

Botticelli's friends—must have sounded to him like the sound of thunder that heralds a resolutory storm, like the echo of another, more real world, more secure and less rooted in the bitter earth of human emotions. As you see, the "romance" is becoming more vivid and intense; evidence of this are the "stories" of Saint Zanobi, which he painted during his last years, in which little remains of the spirit of contraction that had animated the existential difficulties of the man of culture.

The true history of Botticelli took place in the wings or behind the screen of a search for formal perfection. We can have an idea of it —though a pallid one, as is always the case with regard to what happens to others—by limiting our analysis to the study of the nature of its absence, to considering what the fixed eyes of some of his figures see. There are no interpretations more fascinating than those which apparently contradict the official story and the style of the artist who pretends to follow the rules of the game. One can object to the adoption of a reason that might have other explanations, and the objection would hold if—and let me say this once again—Savonarola had not existed and if, within the scope of Botticelli's story, these two diametrically opposed postulates could not be compared.

What did the new culture say to the artist? To believe in life and to accept that reality marked the boundary beyond which human reason cannot operate. And the artist pretended to believe these propositions but could do no less than raise the veil of doubt. This was a doubt that could go in two distinct directions: on the one hand it seemed to claim something more, something that overcame the limits of the new code and which we summarize as shadow, ambiguity and ambivalence; on the other hand, it bared the suspicion that derived naturally from his early happiness and physical joy. It is clear that alone Botticelli —with his artist's tools—would not have succeeded in resolving this impossible balancing act, and it is here that the reason for his twin

following pages
*Punishment
of Korah*
(detail),
1481–1482
Vatican City,
Sistine Chapel

15

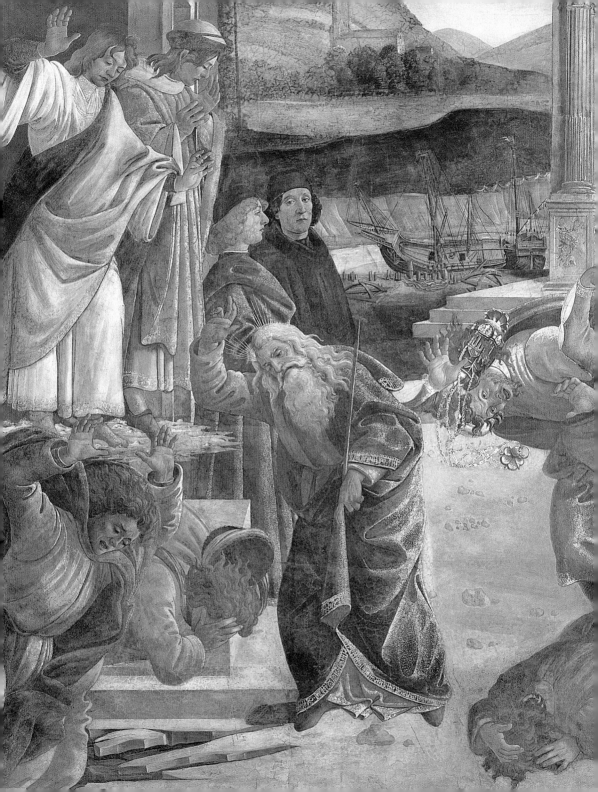

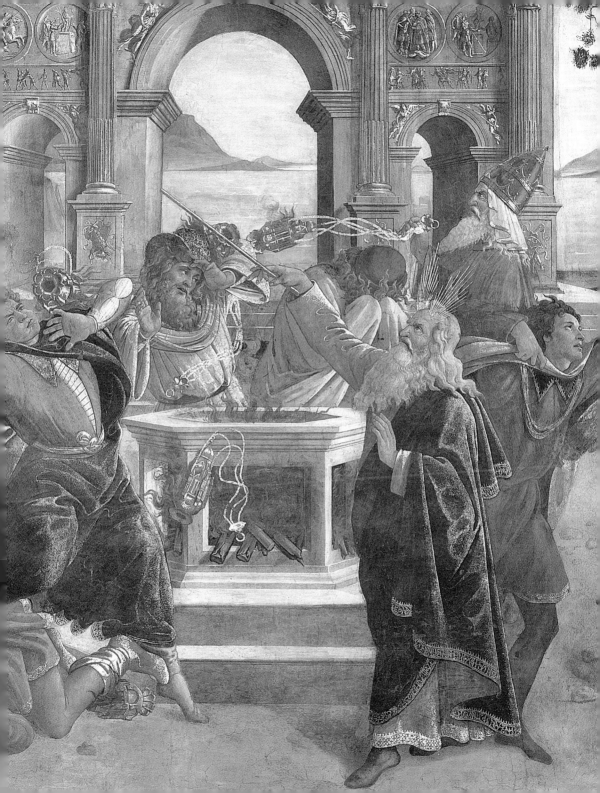

modes of conduct probably lies: the choice of a register that allowed him to construct the world that we see but at the same time to insinuate a doubt into it. To overturn this situation he needed the powerful and cruel arguments of Savonarola, arguments that resembled an act of strength, a gesture of violence to erase from the set of interpretations everything that could generate uncertainty and dissatisfaction.

One might say that Savonarola's ideas were poorly suited to Botticelli's behavior as a man of culture, and this is true, but the artist had no need of material to continue the dialogue, just the opposite: a sponge and a solvent able to soothe him. Once the storm was passed, the cause of his misgivings materially disappeared and Botticelli was able to fill the void that had fascinated him to the point that he had considered putting away his brushes and paints for good.

His interest in and work on Dante's *Divine Comedy* falls within this dialectical vision of his work. Returning to Dante—even if the text was in common, daily use at that time—meant that his idea of composition had found itself another springboard and left neither doubts nor fears. In Dante the artist found a sense of history of the world whose extreme fragility he had recognized. It was the best world to placate reason, and to close the door on the face of doubt.

This, it seems to me, is the relevance of Botticelli and the way to understand his secret, even if his story had a development that, through force of circumstance, remains outside our experience. In Botticelli the books balance, his doubt was resolved by ideas that allowed no possibility of appeal, and the world ended by finding a balance, and even a center. It was from this point that the question becomes more complicated and insoluble for those who, like us, are accustomed to interpreting reality through either classification or disorder. What we have called his modernity lies within the concept of absence: as for the rest, it has the simplest of explanations. The yardstick by which we make our

Madonna and Child with an Angel (Madonna of the Eucharist) (detail), 1470–1472 Boston, Isabella Stewart Gardner Museum

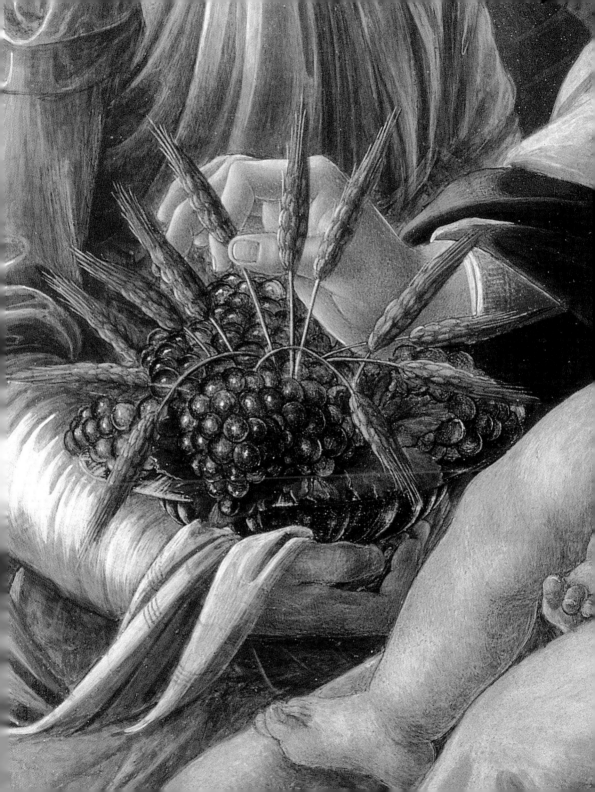

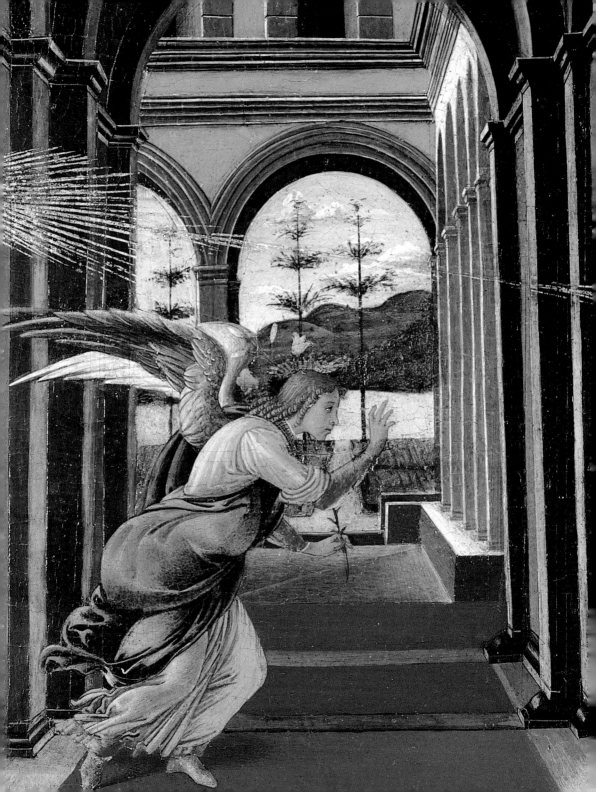

assessment has changed too much for other relationships to be estab-lished, in the same way that this discussion is too disconnected from the laws of his moral philosophy for a comparison to be attempted. However, this had already been alluded to when emphasis was placed on Botticelli's modernity, though this is more a modernity drawn from our own conditions.

Thus, we are led to give a dual reading to what undoubtedly must have been the plight of his existence: on the one hand we consider how we would have been in his place, and on the other we give a more gen-eral and absolute sense to the text. But in both a recovery is possible that avoids the obstacles and dangers of simple aesthetic speculation. If Botticelli were reducible exclusively to the criterion of our pleasure, a discussion like the one we have attempted here would have no sense, and his importance would be severely diminished.

A museum has only one way of being a living institution, and that is to open the door to our justifications and worries. In this case it is the strong cultural contribution of the artist that makes the operation acceptable, or rather which requests the constant engage-ment of these apparently personal relationships, though, actually, they obey different rules. When art resolves its problems with the help of these stimuli, it acquires another dimension and touches on the high-est discourses. In this case, with their very presence, the protagonists of Botticelli's vision run into problems concerning our most secret phys-iognomy. It is the place that one should occupy, and, at a later time, it is the meaning that should be given to our presence. One can never sound out enough the force of certain contractions, the solitude of the drama that the actors in his world perform so effectively. For example, the composition of the *Calumny* leads to a narrower assessment, one that is permitted by the bending forward of the highest figure.

Only with the engagement of religious thinking can Botticelli seem able to overcome the closed bounds of solitude, and then his characters speak amongst themselves and carry out a conversation that elsewhere seems impossible and denied. But first there is a clear separation between men and the world of things and objects: the clarity and bright representation of reality is countered by darkness and secrecy, in short the world of human depths. If the artist seems to evade psychological involvement, he actually succeeds in grasping the tragic intensity of our presence on earth in a simple contrast. It is almost as if the artist were paralyzed when faced by the spectacle of reality and remained enclosed within the bounds of a question unable to express itself.

This theme of charged silence is also very modern and, in many respects, a fascinating one, a little as though the artist had succeeded, somewhere between wonder and the goodwill contracted, in identifying a non-materializable discourse. What has often been referred to as force is none other than the passive awareness of this new situation. The artist invited to assemble the symbols of beauty feels that there is something else behind the image and senses its insidiousness. The precise reckoning seen in Botticelli's works has only one formal point of view, whereas in reality it is the counterproposal of absence and emptiness that determines the course of new thinking.

Do not accuse me of taking these secret suggestions too far. Walter Pater considered the same problem in other terms when he wrote, "But is a painter like Botticelli, a secondary painter, a suitable subject for general criticism?" Pater was considering what was for him the most pertinent point: the quality of the pleasure that artists such as Botticelli can provide. I am more interested in shifting the bounds of the inquiry and considering above all in Botticelli's work what he did not express explicitly, but which he was strongly able to hint at for the future. Pater ended his essay thus: "Studying his work, one begins to understand

how great Italian art was in human culture." In other words, look at what Botticelli did to open the way—a theme that has been commented upon, studied and become a living part of our culture. But by retaining this stance, Botticelli's culture and the culture that Botticelli contributed to promoting is seen from only one viewpoint. The opportunity exists to broaden the debate and to begin to see how much stimulus for novelty, how much active suggestion resided in shadow and secrecy and which made Botticelli one of the first great lights of modern invention.

Botticelli understood that we will never know everything about humankind and he left a trace of this kingdom of the unknown and the ungraspable in his painting.

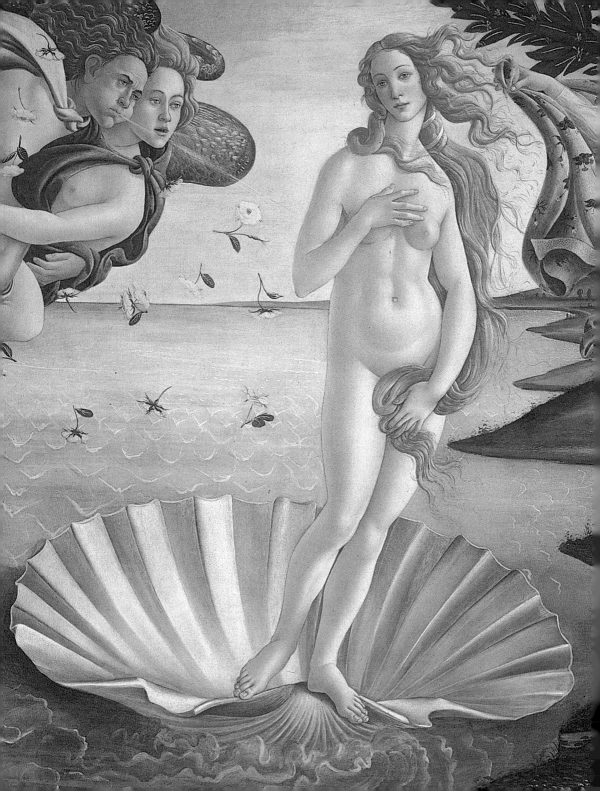

His Life and Art

Botticelli is a difficult subject to discuss. Doing so involves unraveling and organizing information that is sometimes extrapolated or contradictory about an artist who is considered a veritable "sacred monster" of European painting. Surfing on the internet, anyone can see just how many reproductions have been made of the artist's most famous paintings including *Allegory of Spring* or the *Birth of Venus*, today conserved at the Galleria degli Uffizi in Florence. This widespread diffusion nearly five centuries after the painter's death offers no indication of the comprehension of how he worked, and even less any understanding of the role and cultural context in which Botticelli should be placed. It does, however, show that the most evident features of his style continue to be recognized for their appreciable aesthetic value even today.

Giorgio Vasari, author of *Lives of the Most Excellent Painters, Sculptors and Architects*, —published in Florence in two editions (1550 and 1568)—and recognized as the first art historian in the modern sense of the term, refers to Botticelli using expressions that confirm the fame the artist attained in that era and the esteem the Aretine author felt for him. What is interesting here is his insistence on the personality of the painter, who he depicts as a "man of inquiring mind" endowed with an "extraordinary brain." In addition, at the beginning of his biography on Botticelli, Vasari makes a stern rebuke in which he discredits the painter for not being farsighted in the management of the riches he derived from his work and for having fallen prey to the ravages of poverty in his old age. It is believed that these annotations regarding the "extraordinary" quality, which should translate as "mental affectation," and Botticelli's human nature should read both as a precise reference to the artist's position within the cultural milieu of Neoplatonism in Florence at the end of the Quattrocento and as the difficulty involved, already starting with Vasari, in penetrating the profundity of the meanings that characterize the painter's work. It is certain that his fluidity of line and elegant stroke in the paintings were appreciated as salient and qualifying details. He

then falls into oblivion for a long period to be revived only in the midnineteenth century when critics with a Pre-Raphaellite and then decadent approach, from John Ruskin to Dante Gabriel Rossetti (who owned and even retouched the *Portrait of Esmeralda Brandini*, today at London's Victoria and Albert Museum) and D'Annunzio, recognized the model of the melancholy beauty of the epoch in Botticelli's formal solutions, in his vague feminine figures with their hair dressed with "leaves and flowerlets/like the woman in Allegory/who appears in Sandro Botticelli's dreams" (Gabriele D'Annunzio, *Chimera*, 1889).

But what do we know for certain about Sandro Botticelli? We know the neighborhood where he was born—Santa Maria Novella in Florence; his father, Mariano Filipepi, was one of the many craftsmen who made the city rich through his trade as a tanner. Born in 1445, Alessandro was the family's fourth child. In a tax declaration of 1458, which in fifteenth-century Florence was called the *portata*

al catasto, Mariano declared that his thirteen-year-old son was not in the best of health and was doing some work that the document does not clearly explain: *sta a allegare* or *a allegare*. Some take this curious expression to refer to nothing more than school, which the boy was still attending. Others, meanwhile, interpret the expression as an indication that he was doing an apprenticeship (*sta a legare*) at the workshop of a goldsmith, meaning that he was learning the trade of a *legatore di gioie*, or gem setter. Young Sandro's connection to the world of goldsmiths is also mentioned by Vasari, who explains that the nickname Botticelli comes from his presence at the workshop of a goldsmith known as "Botticello" because of his barrel-like build. In reality, critics believe the origin of the name lies in the trade of his brother Antonio who was a *battigello* or *battiloro*, literally meaning gold beater, thus goldsmith. Sandro may have done his apprenticeship at the workshop where one of his brothers worked as well. Training at a workshop other than a painter's should come as no surprise, because in Florence many artists

took their first steps in such a context. These include Ghiberti, Antonio and Paolo del Pollaiuolo, Ghirlandaio and Luca Della Robbia. Workshops employed the "unity of the arts," meaning within them there were craftsmen and artists with specific technical skills, who all participated at their own levels in the creation of manufactured goods. The goldsmith's workshop was thus a sort of gymnasium where even those who would later become painters could learn about definition and attention to detail.

Sometime in the early 1460s (perhaps in 1464), Mariano decided to send Alessandro to the workshop of one of the most important and successful painters of the period: Fra Filippo Lippi. The friar enjoyed the favor of the Medici family and received important commissions from both within and outside the city. One of the striking features of Filippo's work was the realism of his compositions resulting from both his skillful use of perspective and his precision in treating every decorative detail. When in 1467 Lippi was called upon to work on the frescoes at Spoleto's Duomo, Botticelli left his workshop. From that time until 1470 there is no specific information on him and critics believe a group of small Marian paintings on panel may be attributed to this first period. These works clearly show how Filippo Lippi influenced Sandro's first works and just how deep that influence was.

All these early compositions depict a three-quarter view of the Virgin and child, and one or more of the angels and sometimes Saint John. The original model for these is the painting by Lippi *Madonna and Child with Angels* (Florence, Galleria degli Uffizi) of 1465, which had brought great fortune when it was made.

The oldest of these works is the *Madonna and Child with an Angel* conserved at the Galleria dello Spedale degli Innocenti in Florence and which may be dated to 1465. The relationship with the contemporary painting of the *Madonna* by Lippi is clear both in the disposition of the figures within the space, defined in both cases by a window behind the Madonna, and in the pose of the Christ child, whose hands rest on his mother's dress and

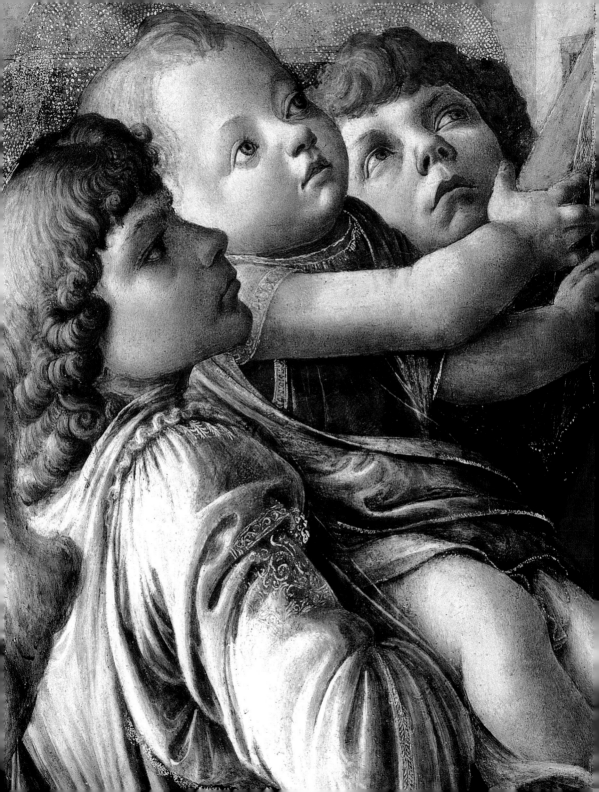

that of the Madonna with her head bowed to the right to look at Jesus. She is seated on a sort of stool that has a scrolled armrest on the side and a cushion whose stuffing is barely held in place by small buttons.

In the *Madonna and Child with an Angel*, which was painted at the same time as the previous one and is conserved at the Musée Fesch in Ajaccio, greater autonomy is apparent with respect to the compositional and stylistic characteristics of the model. Here Maria is depicted standing and the closeness of her face to that of Jesus's confers a greater pathos on the scene. The folds in the fabric of the angel's gown reveal the dynamism of the line.

Some critics, however, have recognized details referring to other influences than those that lead back to Fra Filippo Lippi in these works that may be ascribed to Botticelli's first period. For example, the *Madonna and Child with two Angels*, which may be situated between 1468 and 1469 and is conserved at the Galleria Nazionale di Capodimonte in Naples, shows a sculptural consistency in the figure of Mary that refers to the teachings of Andrea del Verrocchio, while the angels and the Christ child are firmly anchored in Lippi's models. The setting offers more respite with its garden enclosed by a high wall, the *hortus conclusus*, beyond which may be glimpsed a landscape and which is one of the most classic declensions of Marian iconography.

Analogous stylistic modes derived from Verrocchio can also be recognized in the *Madonna and Child, Two Angels and the Infant Saint John the Baptist*, conserved at the Galleria dell'Accademia, Florence. What's more, around the 1460's, the workshop of Andrea del Verrocchio was one of the most active and most prestigious. It constituted a point of reference for younger artists and some of the very best painters, including Perugino, trained within it. Thus, although he was unable to undertake a direct apprenticeship, Sandro, too, would have participated in the decision-making going on in the workshop that contributed, together with the influence of other figures—such as his brothers Antonio and Piero del Pollaiuolo, to

the creation of a sort of cultural and figurative *koine*. A celebrated work, even because it is fairly problematic, the *Baptism of Christ* (c. 1486; Florence, Galleria degli Uffizi) may be taken as an example of the aforementioned: in it has been recognized the hand of Verrocchio, that of Leonardo, and several critics have suggested they recognize the hand of Botticelli.

The theme of the garden signified by the wall is seen again in another work from Botticelli's early years: it is the so-called *Madonna of the Eucharist* (c. 1470; Boston, Isabella Stewart Gardner Museum). Behind the group of Mary and the child with an angel presenting a basket of raisins and wheat is a sort of architectural screen separating the figures from a landscape with a river flowing among hills. This vista may be seen through an opening in the wall between the heads of Mary and the angel. The creation of a scene behind the figures is a solution that returns, in a more conspicuously naturalistic key, in the *Madonna of the Rosegarden*, of which there are two contemporary versions (c. 1470), one at the Louvre, the other at the Uffizi. In both works the rosebush is not just a pleasant decoration; instead, it makes a direct reference to Mary, whose iconographic cannons include the mystic rose. In the Florentine version of this iconography, the scene at the back of the Virgin is framed by an arch with a coffered vault. Supported by two pairs of columns, it combines with the geometric pattern of the marbled floor to create the perspective coordinates within which the scene is set.

To this group of works by Botticelli that may be considered from his debut may be added one characterized by the iconography of the *Adoration of the Magi* (London, National Gallery). The painting may be dated to around 1465 and shows some uncertainty in the architectonic and spatial organization of the scene, which is horizontal, and some confusion in the disposition of the figures who crowd the landscape. The attribution of this painting has wavered between Botticelli and Lippi due to the stylistic similarity in the work of these two artists that is also evident in the perfection of the decorative details.

Pallas,
1494–1500
Florence, Gabinetto dei Disegni
e delle Stampe degli Uffizi

A turning point in the difficult task of recognizing the period of the painter's debut is marked by the painting *Fortitude*, the date of which is certain (1470), as is the prestigious context for which it was commissioned. Concerning the year 1470 we have other information as well that has been extracted from documents. The "*portata al catasto*," for example, shows that Sandro was still in his father's charge, while Benedetto Dei, in his book of *Ricordanze*, presents the artist as being among those who have their own workshop. What is indisputable, however, is that this artist was fully integrated among the most established professionals of the city of Florence. The commission for the panel with the allegorical figure of Fortitude was, in fact, intended as a part of a cycle consisting of seven works, each of which depicts one of the virtues, theological (Faith, Hope and Charity), or cardinal (Justice, Prudence, Fortitude and Temperance). These were intended for the Sala Tribunale della Mercanzia. This institution consisted of six judges, five of whom were selected from among

the members of the five noble professions and were responsible for settling disputes between merchants. Intuition advises us just how important such an organism was in a rich mercantile city like Florence and just how prestigious it was to be commissioned to decorate its spaces. One of the six magistrates was Tommaso Soderini, a notable figure in the city. He was close to the Medici family and a close friendship connected him to another important figure in the city: Antonio Vespucci. A patron of the arts and neighbor of Sandro's family, Vespucci appreciated Sandro's work and could act as an intermediary between the artist and his clients.

At first the panel was commissioned from Piero del Pollaiuolo. However, the painter did not respect the terms of delivery set forth in the contract and his lateness allowed Botticelli to be involved in the creation of two works. Why it is that Botticelli made only one of the paintings is unknown; what is certain is that Botticelli's *Fortitude* reveals an artist who has fully developed his language and is now ready to develop a new sense of space and scenic presence.

Virtue is seated on a somewhat elaborate throne resting on a polygonal step with openwork, supported by little columns; the sides and armrests of the seat are adorned with volutes and it culminates in a vault with a ceiling in fictive marble panels. Light describes the sculptural details of the seat and the shining armor with accuracy; the woman is young and vital, with her head wreathed by a pearl diadem, perhaps in reference to purity, whereas the diamonds on the armor allude metaphorically to the steadiness intrinsic to the Virtue.

Two paintings that were most likely intended to have formed a diptych are dated shortly thereafter (around 1470); these are *Judith's Return to Bethulia* and *Discovery of the Body of Holofernes,* both of which are conserved at the Uffizi. Botticelli offers a simultaneous event in two distinct scenes; in the *Discovery* the anatomical rendering of the youthful nude body laid out and portrayed foreshortened refers back to models derived from Pollaiuolo and curiously contrasts with the amputated head, which looks as though it ought to belong to a

considerably older body. The officials and servants who make the macabre discovery are faithfully described in their reactions of horror provoked by the sight of the cadaver. The atmosphere in the *Return*, in which the two female figures move gracefully and almost weightlessly, their feet barely touching the ground in the soft morning light, is quite different. Their gowns and clothes are rendered mobile by the rapidity of the contour line.

Other works testify to the role that Sandro had acquired by now among the painters of his epoch and prior to his first fundamental stay in Rome in 1481. *The Adoration of the Magi* (c. 1472; London, National Gallery), perhaps commissioned by Antonio Pucci, an important member of the Medici faction, forces the painter to confront the round format. He solves the problem by organizing the composition on two different registers. In the foreground the cortege is arranged in small groups of figures captured during a moment's rest, while the main scene occupies the second plane, where the optical and physical center of the painting converge on the figures of Mary and the Christ child receiving homage from the kings.

A possible commission from the Medici has been observed for the *Coronation of the Virgin with Saints* (Florence, Galleria degli Uffizi). The hypothesis of a possible connection to the Medici is based on the presence in the painting of Saints Cosmas and Damian, the patron saints of the professional category of doctors (*medici* in Italian) and hence of the homonymous family. Furthermore, it was believed that similarities with Giuliano and Lorenzo de' Medici could be seen in the two young, kneeling saints, as provided by the iconographic conventions for patrons. Such hypotheses may be confirmed or rejected on the basis of information available today; the painting is dated to about 1470–1472, on the basis of stylistic comparison with the other contemporaneous works, and the result is a particularly good combination of the positions of figures and their attitudes.

Saint Sebastian (Berlin, Staatliche Museen) is another work that may be dated to the early

1470s (*c.* 1474). It is perhaps identifiable with the painting of the same subject that was located on the pilaster of Santa Maria Maggiore in Florence. The painter indulges in the description of the male physique, ennobling it with markedly dramatic details, and the young saint, despite being depicted immediately after his martyrdom, assumes a pose that is almost unrelated to the contingent events. According to the themes of Neoplatonic philosophy, here Botticelli already seems to intuit a different perception of the relationship between reality and idea. We can almost grasp the first signs of that sort of pensive withdrawal from the contingent events, that "melancholy," to put it in fifteenth-century philosophical terms, which is the distinctive attitude of sages, who are desirous of knowledge and experience everyday events through the sieve of thought. In the background is a landscape rendered with precise detail.

Contemporary portraits are along the same lines. In the *Portrait of Esmeralda Brandini* (*c.* 1475) the characteristic features, although clearly rendered, are freed of every little descriptive detail and suspended in an aura of melancholic thought. The same implicating intensity may be observed in the later *Portrait of a Man with the Medal of Cosimo the Elder* (1475).

The period between 1470 and 1481, the year Botticelli traveled to Rome, is marked by the prestigious commissions in direct relation to the Medici family or to others connected to the family. In fact, his relations within the Medici circles date to the early 1470s, and it is within these circles in the urban palace in Via Larga and in the suburban villa in Careggi that deep philosophical thought in a Neoplatonic key took place and stimulating cultural connections were woven.

It was Cosimo the Elder who wanted to create the Accademia Neoplatonica, a place—the villa in Careggi, to be precise—where intellectuals could fully dedicate themselves to reading, studying and translating Greek and Latin texts and meet to discuss them. The leader of this elite cultural center was Marsilio Ficino, who in the year that

Lorenzo the Magnificent succeeded his father, wrote the commentary to Plato's *Symposium* and sent his work *Plato's Theology* to press. There was such an interest in the Greek philosopher that each year on November 7 —his presumed birthday—that a sumptuous banquet was held in Careggi. It is easy to imagine the discourses that would have been exchanged around the table on those occasions—among others, they would have discussed the immortality of the soul and its inclination toward God propelled by the strength of Love, relieved of any connotation that was too carnal. Thus, earthly beauty was considered one of the most powerful means for accessing the contemplation of divine beauty, which also coincided with Good. The fairly close relationship that tied earthly things to divine things, the first a clear reflection of the second, found one of its preferred means of communication, including visual, in the use of symbols and allegory. Art could thus be useful both for stimulating sensations tied to the world of the Beautiful, and for carrying knowledge to a higher level, through the interpretive effort of the symbols employed.

Botticelli participated in this cultural circle directly and thus became its "official" painter, elaborating the most exhaustive figurative transcriptions of all the Neoplatonic concepts. This is how the *Allegory of Spring* and *Birth of Venus* must be read. These are some of the most famous works by the painter, for whom nature in all its forms becomes the reflection of the Superior Idea that governed creation. In this context, according to the rediscovered authority of Plato, even the divinities of antiquity gain new importance because they become symbols of higher intellectual expression and almost gain a "historic" importance, in that they attest to the different stages in intellectual development, through which men of the past aspired to the deepest understanding of universal harmony. Venus rises up as the perfect personification of the latter. Lorenzo the Magnificent entrusted the education of his homonymous cousin, Lorenzo Pierfrancesco, to Marsilio Ficino who, together with other intellectuals,

acted as an intermediary with the painter. The paintings were to embody philosophical concepts that were otherwise evasive and to draw the attention of the young disciple. This is the context in which the works with mythological, hermetic themes of the early 1480s were born. It is in these works that the painter and the cultural coterie that he belonged to concretely expressed the possibility of realizing a valid beauty principal, both morally and aesthetically. It was a matter of expressing faith in the philosophy that was already formulated in classic antiquity and synthesized in the celebrated notion of *kalós kaì agathós* (the beautiful and generous).

Documents inform us of the stages of this professional affirmation that took place and was fed under the aegis of the Medici. In 1472 Sandro Botticelli was a member of the Compagnia di San Luca, the guild that united the artists at the time, and recorded the works—which unfortunately have not come down to us—that were commissioned by Cosimo the Elder: a standard bearing a "Pallas wreathed with boughs" (Vasari) that was executed for a joust in 1475 (the same one for which the poet Agnolo Poliziano composed his celebrated *Stanze*), the portraits of the persons who were hung for participating in the Pazzi conspiracy carried out at the Porta della Dogana of the Palazzo della Signoria (1478) and a lost *Annunciation* painted in fresco for the same location in the city.

Furthermore, the prestige attained by Botticelli is also confirmed by the notoriety of his workshop, which included many students, such as, in chronological order, Filippino Lippi (1472), the son of Botticelli's old master, followed in 1480 by Raffaello Tosi, Giovanni Cianfanini and others.

Botticelli reflects on the major iconographic themes, such as that of *The Adoration of the Magi*, in an extremely coherent manner. From the first and still uneasy rectangular panel to the one that is more balanced despite its round format (both at the National Gallery in London), he arrives at a full solution to the spatial, compositional and physiognomic

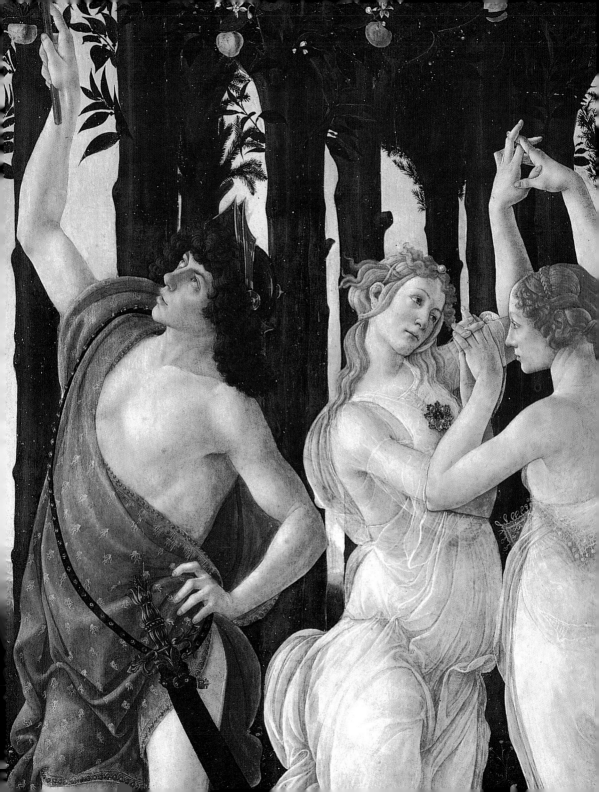

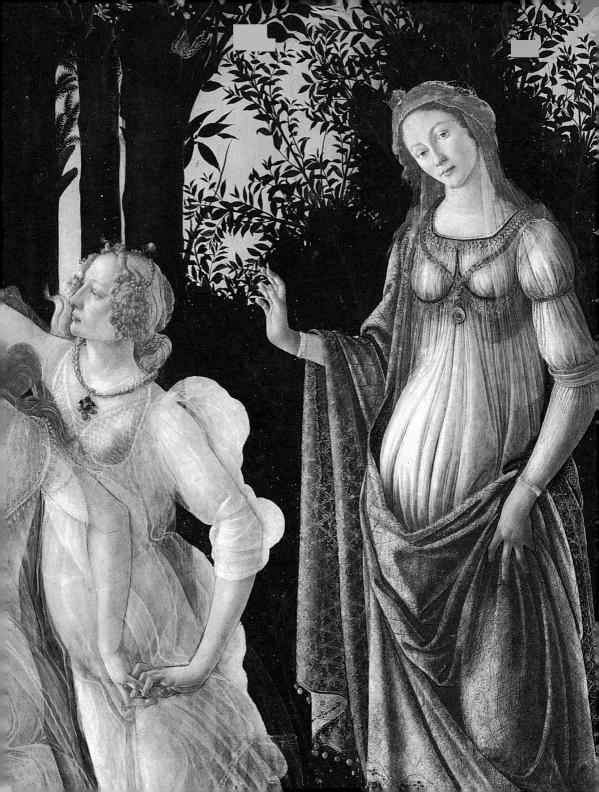

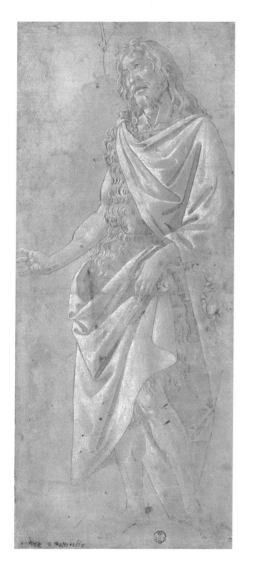

dilemmas involved in the painting for the funerary chapel of Guasparre di Zanobi Del Lama at the church of Santa Maria Novella (1475–1476; Florence, Galleria degli Uffizi), which is famous for its outstanding quality and for the problems identifying the persons depicted. The patron was connected to the Medici family through his involvement in the profitable business of broker in the Bankers and Money-Changers Guild and in addition to the patron, some of the members of the hegemonic family are depicted dressed as biblical figures. In particular, it was believed that Cosimo the Elder and his sons Piero il Gottoso and Giovanni, all of whom were already dead at the time of the painting, could be recognized. Among those present are the painter Pico della Mirandola, Agnolo Poliziano and other figures from the Neoplatonic circle. What is the meaning of all these figures within the painting? The goal was to confer upon them a powerful significance, particularly from a political point of view: it meant attributing a "divine" recognition to their earthly work that they executed

within the values of Christian faith, which strengthened civil faith that is nourished by the philosophical practices, to which the intellectuals of the coterie at Careggi bear testimony.

Finally, the fresco painting with *Saint Augustine* (*c.* 1480) was completed in the Florentine church of Ognissanti (All Saints Church) immediately prior to Botticelli being called to Rome. This work was painted as a pendent to *Saint Jerome* by Domenico Ghirlandaio, as shown by the analogous setting. While Ghirlandaio's Saint belongs, we could almost say more humbly, to the sphere of the everyday, Botticelli's suggests a dimension of profound mediation; in Vasari's words, "this work was very favorably received, for Botticelli succeeded in expressing in the saint that air of profound meditation and subtle perception characteristic of men of wisdom who ponder continuously on difficult and elevated matters." Sixteenth-century critics fully understood the painter's intention: to confer upon the Father of the church an attitude expressing fervent concentration that, according to philosophical categories, should qualify a thinking man. Botticelli paints the saint with great spatial vigor within the small studio filled with books, instruments and furnishings, mindful of the lesson of Andrea del Castagno in the absolute plastic evidence and domination of space present in the cycle of the *Uomini Illustri (Illustrious Men)*, painted by him for Villa Carducci in Legnaia (*c.* 1450). One detail, however, enriches Botticelli's personage with another aspect that is new in part. Until now we have followed a portrayal of a too "inquiring mind," to put it in Vasari's words, Behind the saint, on the left-hand page of the open book, between the geometric figures, is a phrase written in rhyme about the unknown friar Martino: "Where is Brother Martin? He's run away. And where did he go? Outside the city gate to Prato." This tongue-in-cheek citation should come as no surprise. Instead, it should offer us a more appropriate view that allows us imagine the painter as a witty man, ready for a joke; "a good-humored man and much given to playing jokes" according to Vasari. It is well known that he organized memorable practical

jokes in his workshop, such as one at the expense of a friend that led that friend to be condemned for heresy by the Florentine vicar.

In 1481, he painted the fresco of the *Annunciation* for the loggia of the Spedale di San Martino alla Scala, where those afflicted with the plague were admitted. The commission of the painting may be connected to the terrible plague of 1478, by which it assumes the connotation of givingthanks. The scene, set within a courtly, and yet intelligible, architectonic setting, has parts that are of very high quality workmanship, as in the figure of the angel floating in the air, with clothes ruffled by the divine energy of flight, and in the lily the angel holds.

As his call to Rome to the service of Pope Sixtus IV approaches, Botticelli offers proof of his skills, which by then were recognized outside Florence as well, through high quality works that developed and consolidated the painter's fame.

The *Madonna with the Book* (1480–1481; Milan, Museo Poldi Pezzoli) refers to the most ancient paintings on the same theme made during his debut, and it is one of the few panels in rectangular format painted by Botticelli after the 1470s. The Virgin is depicted reading and the infant Jesus leans toward her, clutching nails and a crown of thorns in his hand, foreshadowing his own suffering.

At first, the *Madonna of the Magnificat* (1481; Florence, Galleria degli Uffizi) contributed to the creation of the oleographic and frankly quite obvious image of Botticelli as a painter of Madonnas and drew attention over to the sweet melancholy of the figures (Pater, 1873). However, it constitutes a work of rare efficiency, both in terms of compositional experimentation related to the format and in the quality of painterly workmanship that is truly excellent. The scene of the angelic coronation of Mary, who is intent on composing the Magnificat with help from the Christ child's hand, takes place within an architectural framework suggested by the arch in the background. The entire composition seems knowingly deformed as if compressed within a convex mirror, which, despite realistic data, increases the sensation of the mental vision.

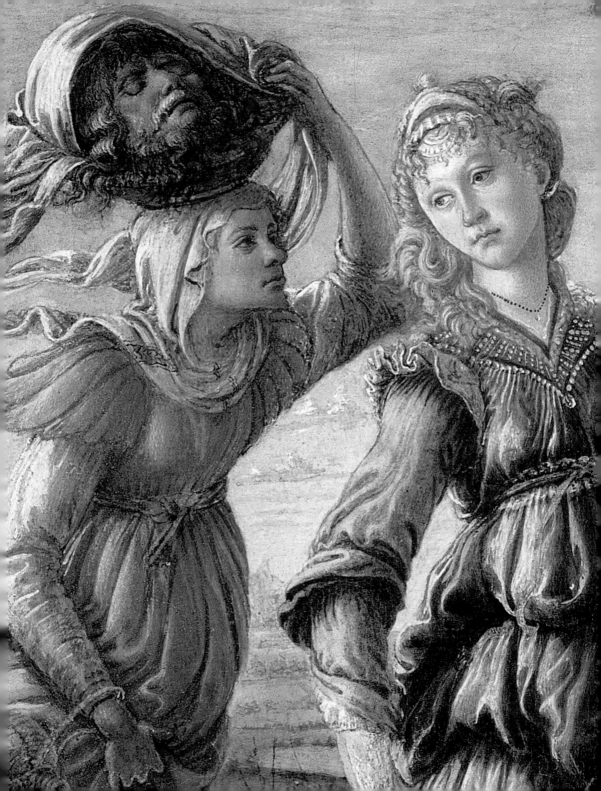

In 1481, Botticelli was called to Rome, where the pope entrusted him, Ghirlandaio, Perugino and Cosimo Rosselli, and later Luca Signorelli and Bartolomeo della Gatta, with the painted decoration of the *magna cappella*, the celebrated Sistine Chapel. Pope Sixtus IV della Rovere played a significant supporting role in the Pazzi conspiracy in which Giuliano de' Medici lost his life. Behind this commission entrusted to, among others, the painter most associated with the Florentine oligarchy, one should discern the end of the hostility between the papacy and the signoria. The pope, a cultured humanist, provided the painters with the iconographic program that included, through illustrations on two facing walls, the comparison of the life of Moses and Christ and the inclusion of the prefigurations that connected the Old and New Testament. The narration begins on the walls near the high altar (the frescoes depicting the *Discovery of Moses* and the *Birth of Christ* were sacrificed by Michelangelo in order to paint the *Last Judgement*) and continue along the north and south walls to end at the chapel's entrance wall. On the upper register, all around the perimeter, there was a long procession of popes. Vasari indicated Sandro Botticelli as the leader of the entire undertaking, but the affirmation must be reevaluated: Botticelli painted three stories, the *Trials of Moses*, the *Temptation of Christ* and the *Punishment of Korah*, and provided the drawings—when he did not participate directly in the production—for eleven popes. The themes should not have caused any difficulties for the painter, because, according to Neoplatonic speculation, the roots of Christianity lie in Judaism. The compositions to which he devotes himself are of an outstanding complexity and are made difficult by the didactic finality that the magniloquent tone constituting the return to stability and to the authority of the church was to join. Moreover, the work executed in Rome makes the painter experiment with the awareness of the symbolic in addition to the spatial importance of ancient Roman architecture, which from this moment on is reproposed—often

elaborated on—wherever iconographic needs require a solemnly majestic setting.

Three episodes are depicted within each panel. In the *Temptations of Christ* the three actions telling the story take place on separate hillocks. The same compositional program is also used for the *Trials of Moses* and the *Punishment of Korah*. These works reveal to us the impression ancient Rome made on the painter: the most evident incidence is his depiction of the Arch of Constantine in the *Punishment of Korah*, nor should we overlook the citation from the *Spinario* or *Boy Plucking a Thorn from His Foot*, a sculpture from the Roman era, copy of a Hellenistic original, that arrived at the Palazzo Capitolino in 1471, or even the probable citation of the Settizonio, a building from the area of Settimio Severo that was still standing in the Quattrocento.

Even the decision to set the Biblical scenes in ancient Rome may be indicative of the patron's desire to bring the subjects up to date, in order to discourage any attempt to dispute the principal of the Roman Church's authority.

The references to antiquity thus must not be considered obliging erudite demonstrations, but rather a recuperation of the feeling of belonging to the *civitas*, to the collectivity organized in an orderly manner in opposition to chaos.

Criticism has, moreover, added another and extremely opportune stylistic reference for the works in the Sistine Chapel, of which the group with the Sons of Jethro in the panel of the *Trials of Moses* is only a particularly evident example: Botticelli kept in mind the formal solutions of contemporary sculpture, in particular Ghiberti's *Gates of Paradise*, in his decision to create the scene with steep and oblique cuts of the hillocks or with the verticals of the trees at the center of the scene.

By the time he returned to Florence from Rome, the painter had fully developed his own language and this led to the creation of a series of extraordinary works for excellent commissions. These are the years in which the coterie of intellectuals at the court of the Medici gave Botticelli the job of interpreting the Neoplatonic culture and bestowing body, faces

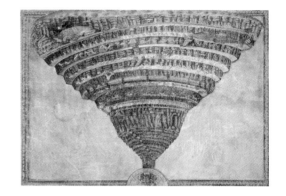

and colors upon the ancient fables and myths that nourished the circle. They are the years of the celebrated allegories, but they are also the years in which a powerful advancement, a thrust toward formal reform, particularly in the works within the religious ambit, could be perceived, and the painter would remain coherent with these until the end.

In 1483 Antonio Pucci commissioned four panels from Botticelli on the occasion of the wedding of his son Giannozzo to Lorenza Bini. At the wedding the tale of Nastagio degli Onesti taken from Giovanni Boccaccio's *Decameron*, was told. The novella is about a young man from Ravenna, Nastagio, who is unhappy because his beloved refused to accept his hand in marriage. After seeing the cruel divine punishment bestowed upon two unhappy lovers, he persuades his beloved to marry him. The novella alludes to amorous tortures that can be defeated and may conclude with a happy marriage. In addition to the hand of Sandro, which may be discerned in the plotting of the story and the areas that

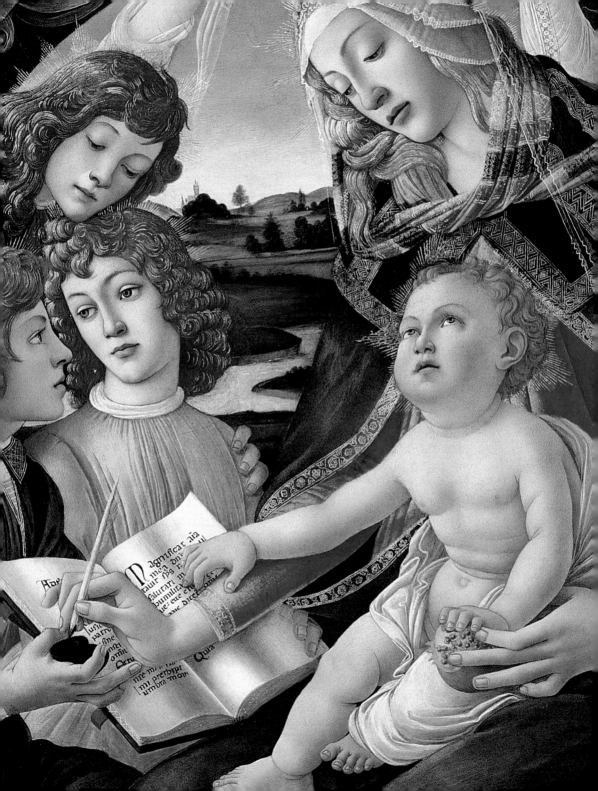

are of higher quality workmanship, the intervention of the workshop may also be identified in these works, which, as their format suggests, would have been set within the wooden molding of a room. The panels with the tale of Nastagio suggest, in our opinion, that, in addition to being familiar with Greek and Latin texts, the Medici entourage recognized the system of chivalric values, which animated this and many other novellas by Boccaccio as valid points of reference.

The storylike tone set in another space in time, within an ambience borrowed from "mythological fable" and nature in the midst of which a sort of pagan rite takes place, is recognizable in one of Botticelli's most famous paintings, his *Allegory of Spring* (Florence, Galleria degli Uffizi), on which entire generations of historians, literati, and art historians have concentrated their work. Critics appear to agree to connect this painting to Lorenzo di Pierfrancesco de' Medici, one of the godsons of Lorenzo the Magnificent. The reasons behind this commission seem to escape all certitude even today; what appears to be certain, however, is the central role attributed to Venus and the relationship with that coterie of Neoplatonic ideas shared by the court of the Medici. Venus is even physically positioned in the center of the painting and in front of a myrtle plant, which is traditionally sacred to her. We discover a sort of mythological paradise in which, to the right, Zephyr, the spring wind, is shown seizing the nymph Chloris, who is about to escape as flowers fall from her mouth onto the transparent dress of Flora. To the left, the Three Graces, Venus's maidservants, weave a dance while Mercury, standing beside them, shoos away clouds with his caduceus, his usual attribute. At the top, above Venus, Cupid, the god of love, shoots his arrows toward one of the three Graces. Behind the figures is a stand of orange trees; a grassy carpet laced with dozens and dozens of flowers constitutes a plane on which the figures appear to be dancing. The efforts to give a final and univocal meaning to the scene described above are never ending. Even the identification of the figures,

which appeared to have been unanimously accepted, has recently been questioned in a new, fascinating and precise rereading that offers a reinterpretation of the subject not so much as *Allegory of Spring*, as a *Wedding of Philology and Mercury*. What remains unquestioned is the placement of the work within a complex group of cultural references to the theme of love, just as the Neoplatonic matrix that informs it and the extraordinary workmanship involved in its creation is irrefutable. In addition to the disarming descriptive detail of flowers and plants, the formal relationship with sculpture, both classical, of which there were also important examples in Florence, and works contemporary to Botticelli, from *David* by Verrocchio to Pollaiuolo. The latter may be referenced by the particular tension conferred upon the line, which creates the gentle and calm rhythm of the figures and substantiates their reciprocal relationships. The dating of a work that is so complex is everything but unanimous. It seems convincing, for stylistic reasons, to accept a date of about 1482, situating it after

the artist's fundamental Roman experience.

Other paintings with mythological themes made by Sandro in the years between his return to Florence from Rome and the second half of the Quattrocento also refer to the same cultural *humus*. The first among these is the so-called *Birth of Venus* (Florence, Galleria degli Uffizi). This work presents even more problems, if this is possible, than the previous one; these are firstly related to its original destination. In fact, it is not included in the 1499 inventory in which many works appear that were made for the younger branch of the Medici family, which had the painting in its possession from circa 1530–1540. Even the title by which it is universally known, datable to the 1900s, does not precisely correspond to this painting's iconography. In fact it is not a birth, but a depiction of the goddess landing on a shore probably belonging to one of the islands traditionally related to her such as Cyprus or Pahos or, even, Citarea. In the center of the painting is Venus, in the *pudica* pose, standing on a shell, blown by the wind

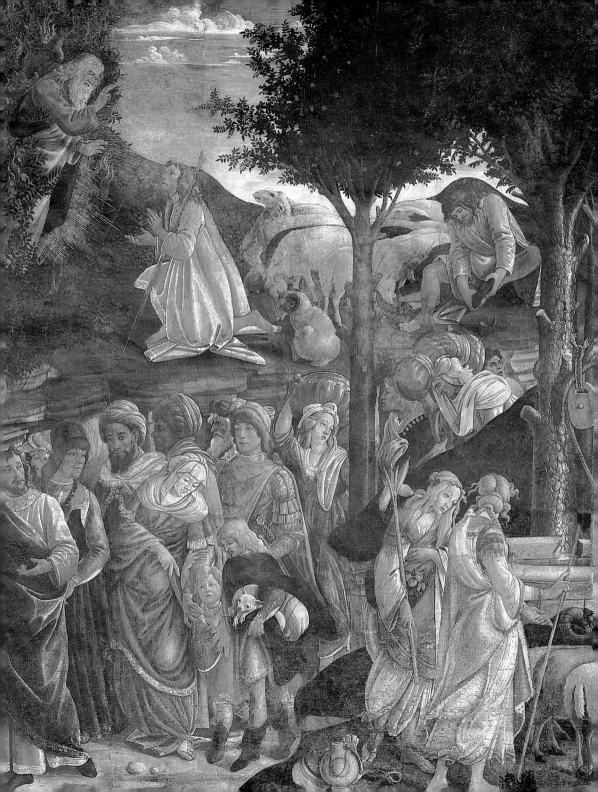

Madonna and Child with Saint
John the Baptist, c. 1468
Paris, Musée du Louvre

(Zephyr), who is embraced by the arms of a nymph; to the right, a figure, probably one of the Hours, or Flora, rushes to pass her a red cloak embroidered with flowers. The quality of the painting is very high, in the minute rendering of the details, in the proportions of the individuals and in their reciprocal relationships. The interpretation of the figure of Venus, understood as the origin of poised universal Beauty, may lead us back to the circle of the Accademia di Careggi. It would thus be possible to push the identification of the goddess toward one of Neoplatonic *Humanitas* depicted in the symbolic act of disembarkation in Florence, allusively represented by the figure of Flora or Hour. The references to the Medici are plenty, and they are evident in the presence of laurel (*laurus*, which contains the root of the name *Laurentius*, Lorenzo) and orange plants that traditionally refer to the family. Even the date of this work is far from being definitively determined, and, based on style, a date of about 1484 appears convincing.

Pallas and the Centaur (Florence, Galleria degli Uffizi) may be compared to the *Birth of Venus* in terms of theme and style, as well as for its provenance from the Medici ambit. On the right of the painting is Pallas, dressed in a light-colored gown on which there are interwoven rings with a diamond embedded in each, indicating an undertaking of Medici origin. Along her arm, on her torso and head are olive branches, on her shoulders is a big shield, while she holds a ceremonial halberd; the other hand holds a centaur, a mythical creature that is half man and half horse, by the hair. He wears a quiver and grips a bow. Even for this painting several different hypotheses for interpretation have been set forth (of political content, in reference to the diplomacy of Lorenzo the Magnificent; of general exaltation of the genius of the Medicis); but the most convincing hypothesis at this time connects the work to Lorenzo di Pierfrancesco de' Medici, to whom it would have been given as a demonstrative image of the dominion of reason and chastity over the brutality of instinct, according to Ficiniani precepts.

The theme of Venus-Humanitas, in contrast to Mars, the god of war and destructive force, is also proposed in the painting *Venus and Mars* conserved at the National Gallery of London. In the foreground, Venus, dressed in a white gown, reclines as she watches Mars, lying supine as he sleeps, unarmed; a few little satyrs are intent upon playing with the god's weapons and armor. The format suggests this work was part of a *spalliera*, or woodwork, intended to decorate a matrimonial alcove. The presence of yellow jackets behind Mars, would confirm this destination, as they constitute an explicit reference to the Vespucci family, which was tied to the Medici family through the marriage between Pierfrancesco and Semiramide Vespucci, celebrated in 1482.

We know that in 1485 Botticelli was entrusted with the execution of two cycles of wall paintings, one of which was to be realized in the Villa dello Spedaletto, acquired by Lorenzo the Magnificent, the other for Villa Lemmi in

Legnaia, which belonged from 1469 to 1541 to the Tornabuoni family, allies of the Medici.

None of the paintings made for the Spedaletto have come down to us because of a fire. Of those made for the Villa near Chiasso Macerelli (later known as Villa Lemmi) in 1873 two scenes that had been whitewashed have resurfaced; these were hanging on the short wall of a hall, while the long one also supported a fresco that is now lost. In light of the iconography of the surviving paintings (Paris, Musée du Louvre) in which a young man is admitted in the presence of the Liberal Arts while a young woman receives gifts from the Graces and Venus, it is hypothesized that the paintings alluded to the nuptials of Nanna Tornabuoni and Matteo degli Albizi, celebrated in 1483. In the scenes two putti holding the coats of arms of the newlyweds' families were also depicted, but are no longer visible; in fact, in nineteenth-century memoirs that recount the discovery of the paintings, one of these coats of arms was identified with the Albizi family. The identification of the newly-weds for whom the works were probably made, however, is not so certain, since another wedding was also celebrated between the two families, that of Giovanna degli Albizi and Lorenzo Tornabuoni (1486). The association of the young man depicted in the painting with Lorenzo, son of Giovanni Tornabuoni, could be justified by the scene in which Grammar, the basis of Philology, accompanies him to the other Arts; it is well-known, in fact, that at the time of his nuptials, the study of the classics still constituted Lorenzo's primary interest.

Botticelli's works depicting mythological subjects in some way mark a highpoint in the painter's development, at least as far as concerns his adhesion to complex and dense iconographical themes with a philosophical bent. Equally difficult for their theological references, despite a superficial, apparent compositional simplicity, are the works with religious and devotional subjects, to which Botticelli devoted himself in the last part of his activity. The commissioned works, even in this area, were made on the behalf of important

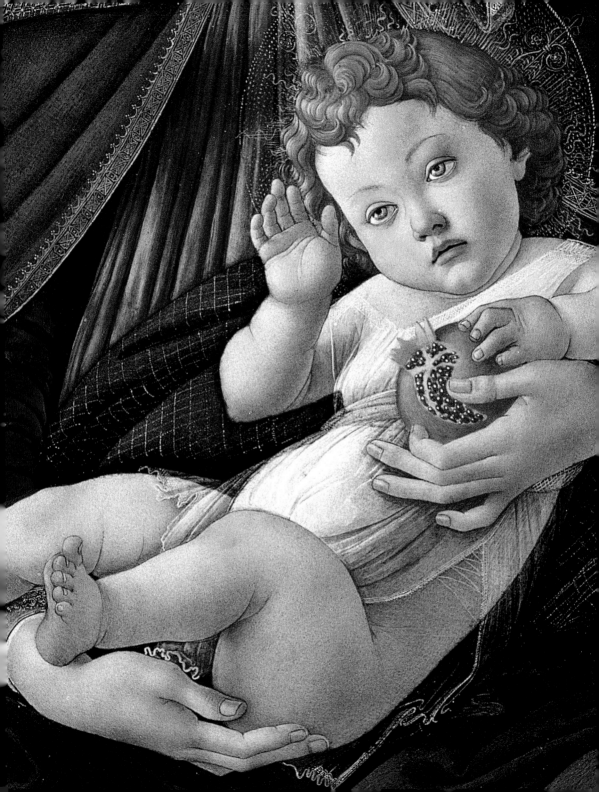

private figures, such as the Bardi family for the *Santo Spirito Altarpiece,* the Guardi family for the *Annunciation*, or prestigious institutions, such as the Guild of Doctors and Apothecaries, for the *Saint Barnabas Altarpiece*, Guild of Silkweavers for the *San Marco Altarpiece*, or the Massai di Camera for the *Madonna of the Pomegranate.*

The first consistent signs of a reforming of the figurative language, which could be substantiated by new religious ferments in Sandro's last period of activity, may be traced to the so-called Bardi Altarpiece (Staatliche Museen Berlin, Dahlem), commissioned by Giovanni Bardi, a member of the prestigious Florentine family tied to the Medici through the bank. Giovanni carried out his mercantile and financial activities in London, but we know that in 1483 he returned to his own city where he acquired a chapel in the church of Santo Spirito. The altarpiece was commissioned from Botticelli and represents Mary enthroned, offering her breast to the Christ child seated on her knee; to the left of the Madonna is the aging Saint John the Evangelist and, to the right, Saint John the Baptist. The setting in which the figures are placed is enclosed by astounding niches consisting of trees bowed together to form alcoves. Some scrolls, with inscriptions taken from Ecclesiastes and from the Song of Songs and referring to Mary, may be seen inserted among the fronds and on vases with olive branches to each side of the throne upon which the Virgin is seated. In the foreground, in front of the step up to the throne, is a vase supporting a small painting of the Crucifixion.

This painting is highly charged in all its apparent simplicity: while the presence of the two saints may be tied to the name of the work's patron, as well as to the city of Florence whose patron saint is Saint John the Baptist, the dogmatic framework, which positions the Virgin and child group along the same axis that cuts the vase and small painting in half, is far more complex. The small container refers to the role of the Virgin as a "vessel" to

receive the Son of God, whose human parable closes with his death on the cross, the only means for guaranteeing humankind its salvation. The redeeming story of humanity could not have happened without Mary, who conceived without the sin of lust, and through the incarnation of the Son of God, which also occurred without sin. In this way the painting may be related to the concept of the Immaculate Conception of Mary, which had not yet been proclaimed as a dogma of the church, but found great support in the Franciscan sphere, which also produced Pope Sixtus IV. The high level of devotion received by the theme in Northern Europe, including England, where Giovanni Bardi lived for a long time, must also be kept in mind. Everything, from the trees (cypress, palm, olive, cedar) to the flowers (lilies and roses) concurs to denote the Mary's function.

From a compositional point of view the painter returns to a traditional tripartite layout, but what is striking here is the subtle contrast between the apparent fixity of the figures and their inner state, described by the light that makes every anatomic detail vibrant, particularly in the Baptist; the same may be said for the rich vegetation, shown frozen in unnatural formations conferred upon it by the painter's fantasy (in particular the niches in the background), and yet seething with life in the Flemish adherence to the real in the botanic details.

Botticelli shows great coherence in his handling of the compositional problems posed by the great altarpieces with religious subjects assigned to them during this period: proof of this lies in the so-called *Saint Barnabas Altarpiece* (Florence, Galleria degli Uffizi), made around 1487 for the Guild of Doctors and Apothecaries and placed in the homonymous Augustinian church. The saint who lends his name to the altarpiece was the patron of the Guild, but the Florentines also associated him with the victory over Arezzo in the Battle of Campaldino (1289). The painter's attention seems to concentrate on architecture, which is rich with references to classic antiquity, such as in the pilasters that flank the throne or in

the relief work decorating its steps. The space is described with magniloquence and articulated grandly, almost amplified by the gesture of the angels holding back the curtains of the canopy at the top.

An inscription placed beneath the throne cites the verses from the prayer that Dante has pronounced to Saint Bernard in the last canto of the *Divine Comedy*. The citation is not at all haphazard as we know that Botticelli spent much time with Dante's poem, making many drawings for it (most of which are conserved in Berlin at the Kulturforum Villa Oppenheim, while a small number are at the Biblioteca Apostolica Vaticana). The painter devoted himself to their creation for Lorenzo di Pierfrancesco de' Medici beginning from around 1480 until 1495. Guided by Neoplatonic suggestions, in 1481 an edition of the poem was produced together with commentary by Cristoforo Landino and the Dantesque journey, a *gradus* towards the vision of Good; it must have found a good soundbox within the Medicean entourage.

The citation's position in the painting, its content and the rhetorical disposition of the words composing it all seem to constitute the most appropriate commentary on this work, at the center of which is placed once again the redeeming journey guaranteed to humankind by the sacrifice of the Son of God through the double role of Mary as mother and daughter of God.

It is to a period (1487) slightly later to that of the *Saint Barnabas Altarpiece* that the critics date the circular painting of the *Madonna of the Pomegrante* (Florence, Galleria degli Uffizi), in which space assumes great importance despite the small size of the work, expanding within the circle of angels around Mary.

The commission of the *Cestello Annunciation* (Florence, Galleria degli Uffizi), instead, dates to 1489; its name was adopted from the church in which the work belonging to Cistercian monks was found. It was commissioned for the family altar by Benedetto Guardi del Cane, whose coat of arms is visible in the lower corners of the

original frame that is still with the painting. The scene takes place in a barren room defined by the firm architectural layout; the vanishing point of the squares of the floor leads the viewer toward the hands of the protagonists that stand out against the gray background of the close walls. In the back, a door brings the third protagonist into the scene: the beautiful landscape evoking a Nordic atmosphere.

The true apex in the production of anconas with sacred subjects was reached with the *Incoronation of the Virgin* (1489–1490; Florence, Galleria degli Uffizi), also known as the *San Marco Altarpiece* because of its original location in the Florentine church of the same name. The Silk Weavers Guild, which also included the Goldsmiths Guild at the time, commissioned the painting between 1488 and 1490 for the chapel dedicated to the patron saint, Saint Eligius.

This work shows a new compositional typology, anticipating sixteenth-century solutions with a clear separation between the two planes that make up the scene, the human one below and the divine one above. In the lower part stand four saints in the strength of their nearly sculptural physical evidence outlined by a soft light; Saint John the Evangelist stands out in particular. He is shown with an open book in one hand, while the other is raised, pointing toward the scene that inspired his Apocalypse and outlining its prophetic significance, in which, moreover, the exegesis recognized the anticipation of the Assumption of Mary. A mystic fervor emanates from the Saint's face and there is a sort of crossreference between the dark blue of the jacket and the red of the mantle of John and those, used inversely, of the Eternal Father.

Even the presence of saints Augustine and Jerome, the second and third from the left, may be explained through the importance of texts attributed to them in which the Marian mystery of the Assumption is examined. The landscape in the background is greatly simplified and is in keeping with the clearness and the spatial significance of the saints, which

contrasts, in the upper part, the glittering of gold and the movement of the angelic carol that weaves around Mary and God. The presence of the blue cherubim and red seraphim, arranged in a double ring around the divinity, seems to constitute both a formal reference to the drawings to illustrate the text of the *Divine Comedy*, and a conscious recuperation of details taken from sacred representations. These would thus be the first signs of the mystic awakening that would mark the last phase of the painter's spiritual and artistic life, which coincide at this time.

The first to support Sandro Botticelli's belonging to Savonarola's *piagnoni* was Giorgio Vasari: "Botticelli was a follower of Savonarola. [...] He remained an obstinate member of the sect, becoming one of the *piagnoni* or snivelers, as they were called then, abandoning their work; so finally as an old man, he found himself so poor [...]." But how much truth lies in these somewhat malevolent affirmations has been established by critics, which have greatly reevaluated the

extent of the painter's involvement in the movement that grew up around the Friar from Ferrara. In the city, two opposing factions were formed, that of the *piagnoni*, who passionately followed Savonarola and his preaching, and that of the *arrabbiati*, or those who equally passionately opposed Savonarola and refused the moralizing exhortations of the sect. The two groups had violent encounters in the city streets, confirming the inhabitants' feeling of insecurity that had been latent for some time.

The last years of the century in Florence, particularly after the death of Lorenzo the Magnificent in 1492, were scarred by internal political problems caused by spreading discontentment with regard to the Medici management of power and problems in international politics and the defense of the boundaries menaced by Charles VIII, who descended into Italy with his troops two years later. Shared until this time, the ideals of the government model and

the model for civil development, of which Florence, with its court and intellectuals, had been the catalyst, entered into crisis. It comes as no surprise that in such a situation "the authentic concern of the best spirits" (André Chastel) reawoke and was channeled into a form of revival of the mystic and prophetic themes. Paradoxically, the philosophical practice made it easier to thrive on religious fervor, which had remained dissimulated and was fed by the providential dimension that also informed much of Neoplatonic thought in the preceding years.

Savonarola, called back to the city by the Medici after a first sojourn in Florence and a subsequent removal, gives body and voice to petitions for renewal and moralization that brought together a broad array of the Florentine population, with disregard for the different social positions.

Sandro Botticelli was not a true follower of Savonarola, unlike his brother Simone, with whom he lived. That a superposition in the last part of the painter's life, a distinct kinship to some of the themes shared by many, including the *piagnoni*, may be distinguished is another matter. Within this context are born the last works with sacred subjects, and explanations may be found for the artist's formal choices, the most significant of which is the simplification of compositions that characterized the works he painted within the religious and devotional ambit. His refusal of descriptive detail also matures along this vein, and it is this refusal that so characterized his mature work. It cannot be proved, but there is a well-founded, in addition to indicative, hypothesis that the decision not to indulge in the use of descriptivism and minute detail may be related to Savonarola and his preaching ("you would do well to erase these figures that have been painted so dishonestly"). In the same way, certain details related to visions with an apocalyptic bent are present, for example, in the *Mystic Crucifixion* (1498–1500; Cambridge, Mass., Fogg Art Museum).

Equally voluntarily, the painter resumes

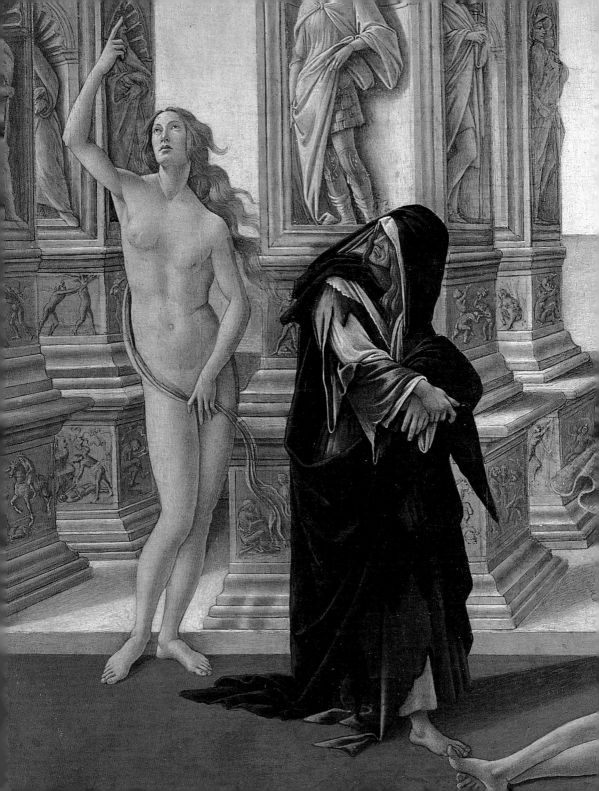

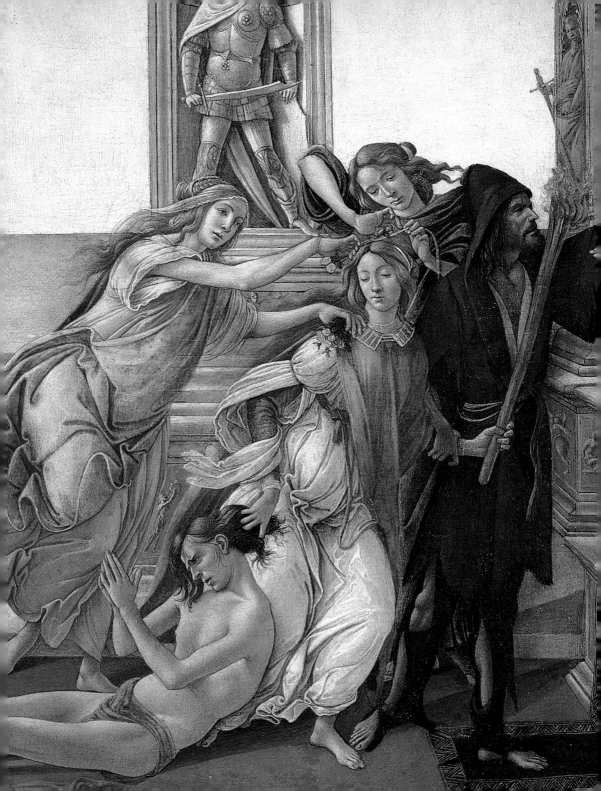

the use of archaizing schemes that are well adapted to the complicated symbology employed to recount the sacred themes. This is the case in the celebrated *Mystic Nativity* (1501; London, National Gallery), in which the figures of the dancing angels have lost the serene beauty of those in the *Incoronation of the Virgin* at the Uffizi to assume a celestial incorporeity.

With the end to his life and career—exceptional for its duration and intensity—close at hand, Botticelli owned a prestigious workshop that continued production that stagnated in a standardized iconography, because it was freed from the painter's deep religious and spiritual motivations of his last programs that were dear to a patronage that was sensitive to the simplified and more immediate devotional features.

The legacy of the architectural setting involving great commitment and impact did not abandon the artist, rather it returned with a new vigor in his last profane allegories, the *Calumny of Appelles* (1495; Florence, Galleria degli Uffizi), the *Story of Lucretia* (1500–1504; Boston, Isabella Stewart Gardner Museum) and the *Story of Virginia* (1500–1504; Bergamo, Accademia Carrara), in which his study of the harmonious blending of elements and the compositional articulation of groups of figures, too, could come to fruition.

For the last time, the painter draws on his own culture, fed by classical examples rich with extensive figurative references ranging from antique and contemporary statuary to examples from Nordic cultures and what painters younger than he, such as Leonardo and Michelangelo, were creating.

"Anyhow, after he had grown old and useless, unable to stand upright and moving about with the help of crutches, he died, ill and decrepit [...]"; Vasari restituted a bleak image of the last part of the painter's life and it is possible that, in the early sixteenth century, Botticelli was considered an artist who had become marginal, a spectator overshadowed by the extraordinary new assertions of younger artists.

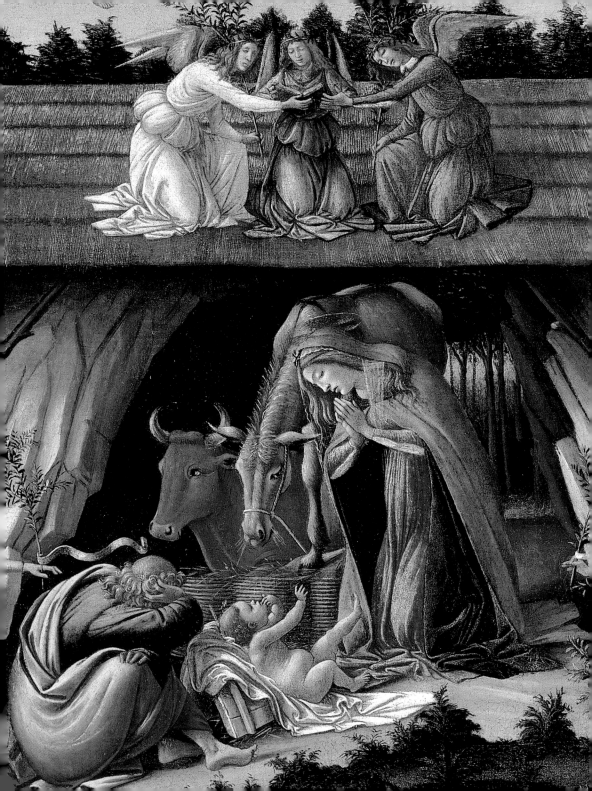

The Masterpieces

Madonna and Child with Angel

after 1465
Tempera on panel, 110 × 70 cm
Ajaccio, Musée Fesch

This work belongs to the artist's first efforts as an independent painter, which may be intuited not only from his style that is close to that of Filippo Lippi's, but also from Mary's standing position and above all the generally weak composition. The predominant characteristic is the accentuated decorativeness as the drapery demonstrates and which is impacted by the light and the idea of the festoon draped around the upper part of the painting. This area reveals some uncertainties in the rendering of the natural features. It is clearly an early work even because it is possible to make out the beginning of a rhythmic lyricism that would be found in successive works.

The distribution of the figures within the space is also unclear due to the lack of any distinct perspective point: the fake marble floor appears to be a plane inclined toward the viewer, causing the protagonists in the painting to almost appear to be slipping.

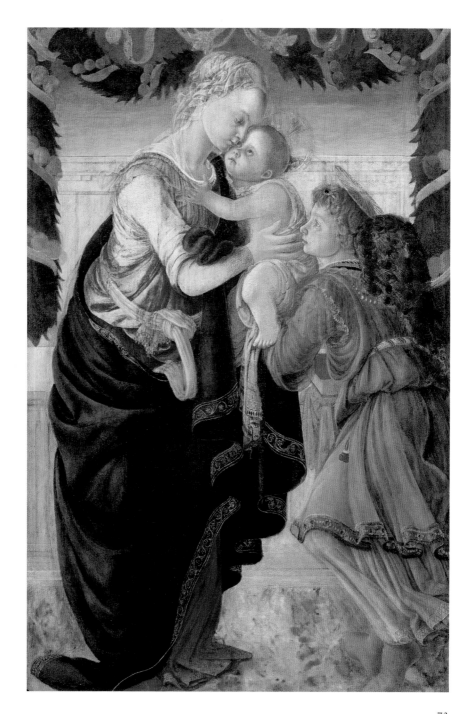

Madonna and Child

c. 1467
Tempera on panel,
71.6 × 51 cm
Avignon, Musée du
Petit Palais

This painting can probably be dated among the first works of the artist, which precede the paintings of the same subject at the Gallerie dell'Accademia in Florence and at the Galleria Nazionale di Capodimonte in Naples. Here he experiments with the possibility of opening up the Madonna and child group, which is usually a fairly tight composition as in the models by Filippo Lippi, from which many of Botticelli's early works took their inspiration.

Here, too, appears the arch that frames the figures; this motif is more fully formulated in the *Madonna of the Rosengarden* in Paris. The superb hand with which the Virgin produces her breast, a reference to the influence of Verrocchio, is noteworthy. The iconographic theme of Mary producing her breast for her son was widespread and is tied to the theological consideration that developed along two essential themes: the incarnation of God and Mary's role as mediator. Bernardo di Chiaravalle was one of the most ardent supporters of Christ's devotion to humanity and his redeeming action through Mary. From a strictly devotional point of view, paintings such as this were most likely made for domestic purposes and belonged to the ambit of cults pertaining to maternity and infancy.

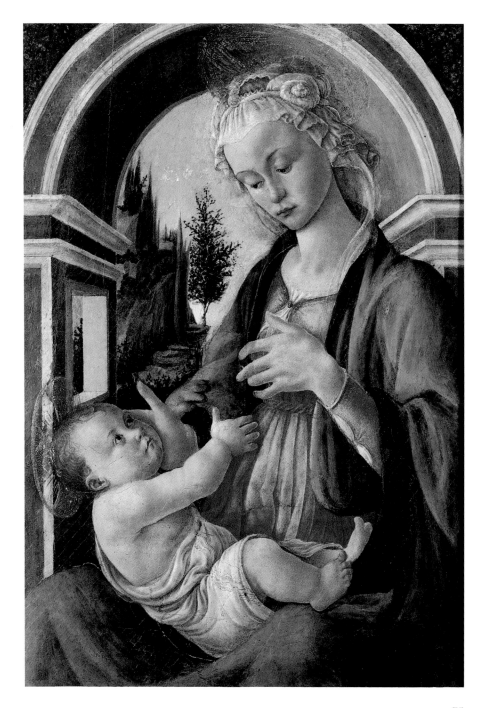

Madonna and Child
(Madonna della Loggia)

1467
Tempera on panel,
72 × 50 cm
Florence, Galleria degli Uffizi

This painting has not been unanimously included in the listing of works by Botticelli. Those critics who have accepted its authenticity recognize in it some of the characteristics of Botticelli's early work, such as, for example, the definition of the drapery and the light that may be likened to Verrocchio's style. Researchers who contest the attribution refer to the brownish tint that is not present in Botticelli's pallet and the deformity of the composition, not only with respect to Filippo Lippi's models, to which Sandro's early works are closely tied, but also with respect to other early paintings that are attributed to him.

Some specifications are possible: the brownish tone may be justified in part by the presence of many touch ups that altered the painting's material; the composition set within the architecture of a loggia, even in its rendering of space that is not yet precisely coordinated and is a bit mechanic, could fall into the typology of the oldest works by the painter, who was interested in experimenting with the different possible combinations of the group depicted within an architectural framework.

Two other works with similar subjects have been examined alongside the painting: one from the Art Institute of Chicago, the other from the Los Angeles County Museum, Norman Simon Foundation; however, critics seem to agree that the latter two may be eliminated from the œuvre of Botticelli.

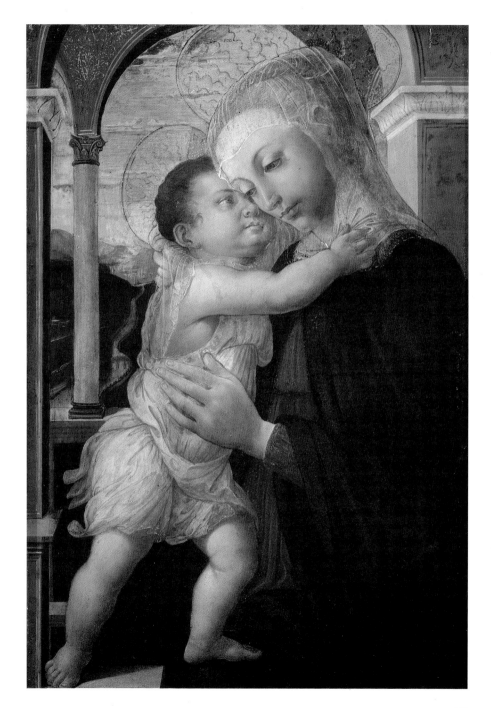

Madonna with Child and Two Angels

1469–1470
Tempera on panel,
100 × 71 cm
Naples, Galleria Nazionale
di Capodimonte

This painting was previously attributed to Filippo Lippi; modern critics, instead, almost unanimously assign it to Botticelli. Although it betrays a strong influence to Lippi, in this case the rendering of the volumes in the figure of Mary, which is more markedly sculptural, reveals the painter's impact with the new potential strength attributed to the line of Andrea del Verrocchio. Critics then recognized the strength of the lesson of Verrocchio, from which it may be deduced that he trained for a certain period at the master's workshop.

Analogous stylistic components have also been observed in the *Madonna and Child with Saint John and Two Angels* (Florence, Galleria dell'Accademia). The face types make it possible to give the work a date close to that of *Fortitude* and other Madonnas from the painter's youthful period. From an iconographic point of view, the architectural component is limited to the enclosure wall separating the open space in which the scene takes place from the exterior space; it is a clear reference to the *hortus conclusus* (enclosed garden), a traditional allusion to Mary's virginity.

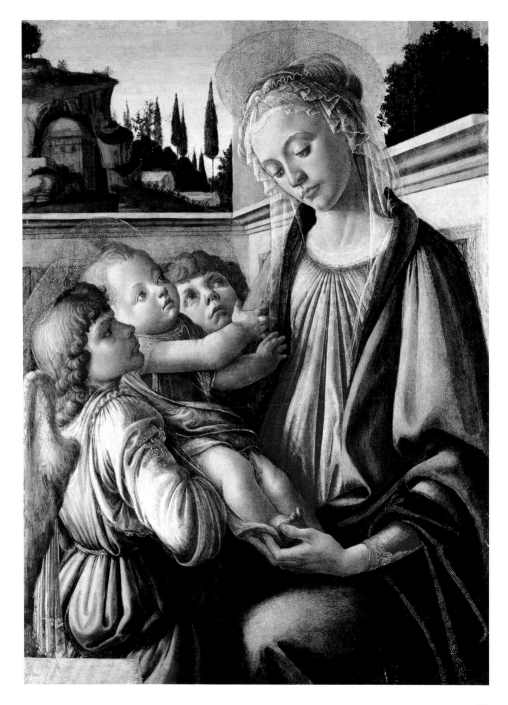

Madonna and Child
(Madonna of the Rosengarden)

1469–1470
Tempera on panel,
124 × 64 cm
Florence, Galleria degli Uffizi

It has been suggested that this work belongs, together with the *Madonna della Loggia* and the *Madonna and Child in Glory* (both Florence, Galleria degli Uffizi), to a group of paintings originally intended for the Wool Guild. In fact, they came to the Uffizi toward the end of the eighteenth century from the Chamber of Commerce, whose headquarters were located there. The work, together with the *Madonna in Glory*, is dated around the same time as *Fortitude* (1470; Florence, Galleria degli Uffizi), because of the stylistic affinity in the faces of the female figures and the fact that they are tilted slightly to the left.

The space in which the Virgin and child are placed is firmly structured and this is emphasized by the repetition of the rectangular motif and by the symmetry of the coffers in the archway and the inside of the window frame and the glossy marble floor. The presence of the rose behind Mary is justified by the custom of conferring upon it the attribute of the mystic rose, while the pomegranate she is holding and from which the Christ child is about to eat some seeds is a traditional reference to the resurrection.

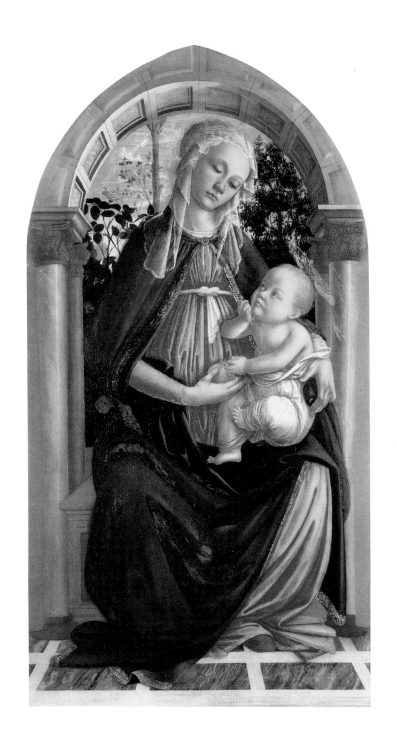

Fortitude

1470
Tempera on panel,
167 × 87 cm
Florence, Galleria degli Uffizi

Fortitude constitutes a chronological certainty in Botticelli's œuvre because the context and the patron for which it was made, as well as the date of its execution, are all known. It was one of a series of six panels illustrating the six Virtues, and they would have decorated the Sala Tribunale dei Sei, or della Mercanzia, located in the Palazzo della Signoria. The work was originally commissioned from Piero del Pollaiuolo and, perhaps because of a delay in the delivery of the paintings, Botticelli became involved, but he only completed *Fortitude*. It has been thought that Giovanni Antonio Vespucci, also a member of the Medici faction, and who lived a cross street of the painter's Ognissanti neighborhood, in addition to being the tutor of Piero, Botticelli's brother, probably played a role in such a prestigious commission.

This painting is a kind of milestone for the artist: stylistic comparisons have made it possible to draw up similarities and pinpoint the stylistic evolution of the artist's work. *Fortitude* is a painting with a firm spatial layout, its sculptural relevance defined by the line, and the altogether original creation even as far as concerns its iconography. Usually depicted with helmet, shield and sword, all missing in this case, here Fortitude is presented wearing a coat of armor and holding a bludgeon, the form of which evokes another of her attributes, the column. The cold, clear light reflects on her armor and on the diamonds that are set into the metal, making the pearls—an obvious allusion to purity—on her diadem glow, and highlights the luxurious acanthus foliage on the volutes of the throne.

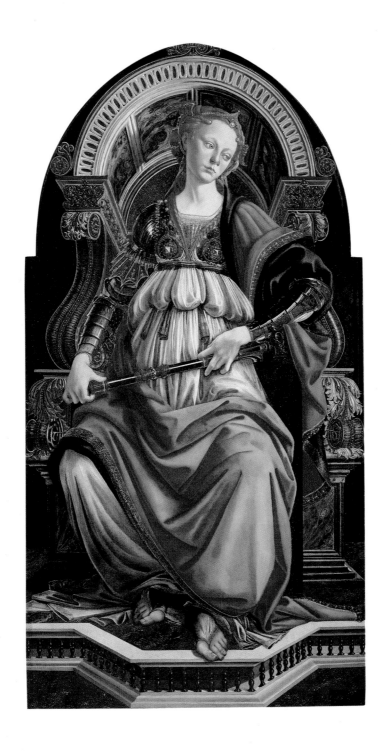

83

Stories of Judith
Judith's Return to Bethulia

1470–1472

Tempera on panel,
31 × 24 cm
Florence, Galleria degli Uffizi

Together with the *Discovery of the Body of Holofernes*, this work was a pendent that very probably formed a diptych. The two works are documented together in the Medici collections at the end of the Cinquecento. Critics agree on their attribution to Botticelli, while the work's date is not univocal; nonetheless it varies little and is reported as being about 1470. They narrate two episodes in the story of Judith, the heroine of the Hebrew's, who in order to pull her native city Bethulia out of the long Assyrian siege, devised a plan for salvation. The story comes down to us in the Apocrypha of the Old Testament: the beautiful and rich widow, after dressing to make herself very appealing, went with her maid to the camp of the adversary. Here she succeeded in gaining the confidence of the enemy commander, Holofernes, by pretending she wanted to collaborate with him in order to accelerate the city's surrender. The general becomes enamored of her and, in his attempt to seduce her, invites her to a banquet. Left alone, the drunk soldier falls asleep and Judith kills him by decapitating him. Macabre trophy in hand, the two women furtively flee the camp and return to the city. Stylistically, the most relevant date comes from the fusion of the landscape and the figures, defined by the rhythm of the line, which is indebted to the experiments of Antonio del Pollaiuolo. In it, critics have fairly regularly recognized a connection to the *Embroidered Vestments of Saint John* (Florence, Museo dell'Opera del Duomo), for which Pollaiuolo provided the drawing and upon which work began from 1466, and in which the attitude with which Judith holds the sword is reflected. The terse atmosphere of the landscape, in which the female figures seem to walk suspended over the ground, contrasts with the horror described in the other painting. The biblical episode of Judith, who murders the oppressor of her people, recurs in the iconography of the Quattrocento as a symbolic allusion to liberty and victory over tyranny; in this case, the olive branch in Judith's hand appears as a symbol of peace.

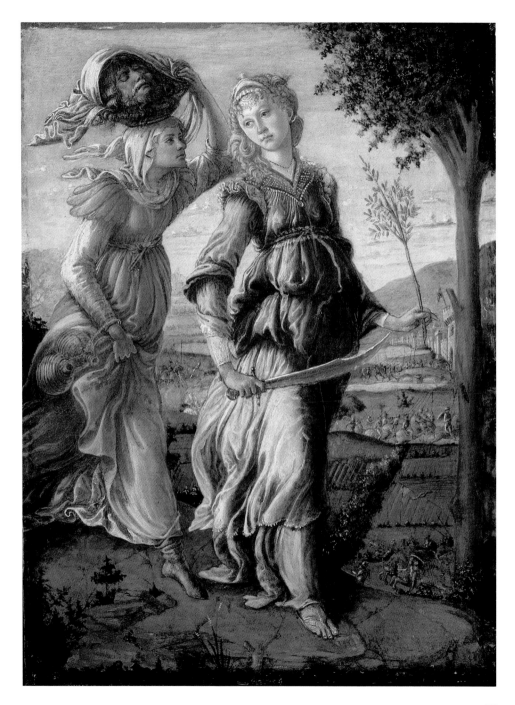

Stories of Judith
Discovery of the Body of Holofernes

1470–1472
Tempera on panel,
31 × 25 cm
Florence, Galleria degli Uffizi

This work, together with the preceding one, very probably formed a diptych. They are documented together in the Medici collections at the end of the Cinquecento. Critics agree on its attribution to Botticelli, while the work's date is not univocal; nonetheless the dates attributed vary little and it is reported as being from about 1470. The generals and Holofernes' guards, not seeing him at camp, go to the tent only to discover the horribly mutilated cadaver.

The anatomy of the male body is truly an example of the bravura of the painter, who uses light to describe the details minutely and naturalistically. A fairly close relationship has been recognized with Pollaiuolo, who provided the drawings for the embroidered vestments of Saint John (Florence, Museo dell'Opera del Duomo), particularly in the energy of the line, apt for describing the excitement of the figures compressed into the tight space of the curtain. The light makes the surfaces vibrant and gives a plastic definition to the shapes.

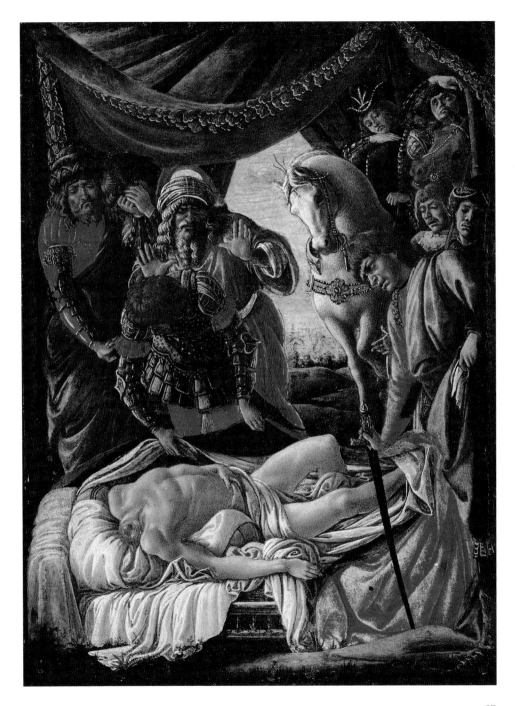

Portrait of a Young Man

c. 1470
Tempera on panel,
51 × 33.7 cm
Florence, Galleria Palatina,
Palazzo Pitti

The critics assigned various authors to this painting over the decades, until it was finally added by mutual consent to Botticelli's body of work. The young man depicted in the portrait emerges from the background confidently, revealing a noteworthy sculptural quality. Many revisions have been pointed out in the band of cloth resting on his shoulder, reinforcing Botticelli's paternity of the painting, a perfectionist and tormented professional of drawing.

Our painter's activity as portrait maker dates to the beginning of the 1480s. Botticelli appears as an attentive connoisseur of both the Italian portrait painting tradition at the beginning of the Renaissance, when figures were represented almost exclusively by profile, and the innovation brought to the genre by the Flemish, who were the first to experiment with the three-quarter position. Painters such as Botticelli preferred a more realistic setting over the neutral or monochrome backgrounds, using the landscape or inserting the figure within an architectural framework.

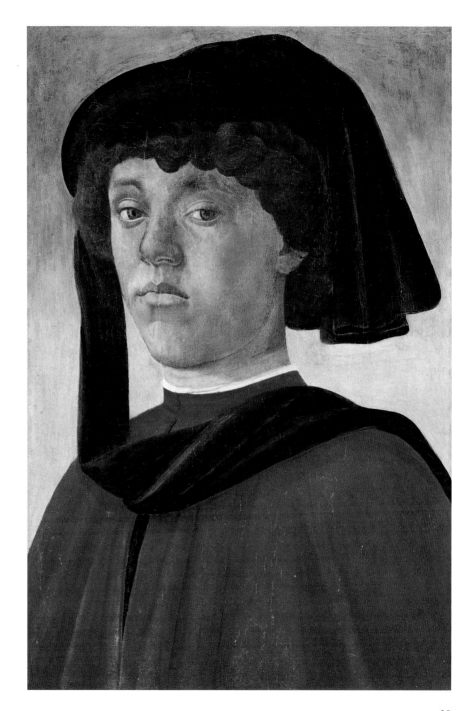

Scenes from the Legend of Mary Magdalene Ascending to Heaven, and Her Last Communion

c. 1470

Tempera on panel,
18 × 42 cm
Philadelphia, Philadelphia
Museum of Art, The
Johnson Collection

The works (*Listening to Christ Preach*, *The Feast in the House of Simon, Noli me tangere*) show episodes from the life of Mary Magdalene taken from the medieval legends that brought us the key points in the lives of the saints. In reality, in the case under study, the episode of the Communion and the Assumption seems to associate Mary Magdalene with Mary of the Egyptians within the iconography; the latter is also an archetype of conversion and contrition. The biggest problems with respect to the predella being discussed here concern the original context of the work, whose identification is uncertain: according to some, it would belong to the so-called *Convertite Altarpiece*; critics recognize it as the *Saint Ambrogio Altarpiece* at the Galleria degli Uffizi, still others connect it to the *Trinity* at London's Courtauld Institute Gallery. Stylistically, the stories may be compared with works from the 1470s, as far as concerns the use of light as in the two *Adoration of the Magi* conserved in London (both at the National Gallery), for example, or the relationship between architectural space and the figures, which is far from achieving the magniloquence of the artist's mature works.

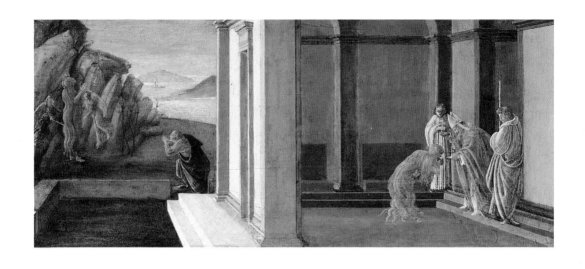

Madonna and Child with an Angel
(Madonna of the Eucharist)

1470–1472
Tempera on panel, 85 × 64.5 cm
Boston, Isabella Stewart
Gardner Museum

In terms of style, this painting shows an evolution in the conquest of space by the figure, which is characterized here by a renewed firmness. Even the opening onto the landscape occurs with full mastery of technique in the beautiful solution of the wall in which a kind of window opens out onto a riverscape. The idea of the wall with a corner, in which the figures are placed, recalls the analogous solution adopted in the *Madonna and Child with Two Angels* at the Galleria di Capodimonte, in which, however, it is easy to measure the distance. Particularly noteworthy is the angel's smile, inspired by Verrocchio's models, which expresses a tenderness toward the Christ child that was unknown in paintings by Botticelli.

The basket with the raisins and wheat that the angel offers Mary is the motif from which the work takes the title that is generally used. The fruit would be an explicit reference to the wine and bread of the Eucharist and thus an allusion to the mystery of the incarnation of God. This iconography has also been connected to Neoplatonic philosophy, making it possible to perceive a reference to the tension between Love and Beauty that emanate from God, the reflection of his perfection, expressed through a far more subjective and transitory physical beauty.

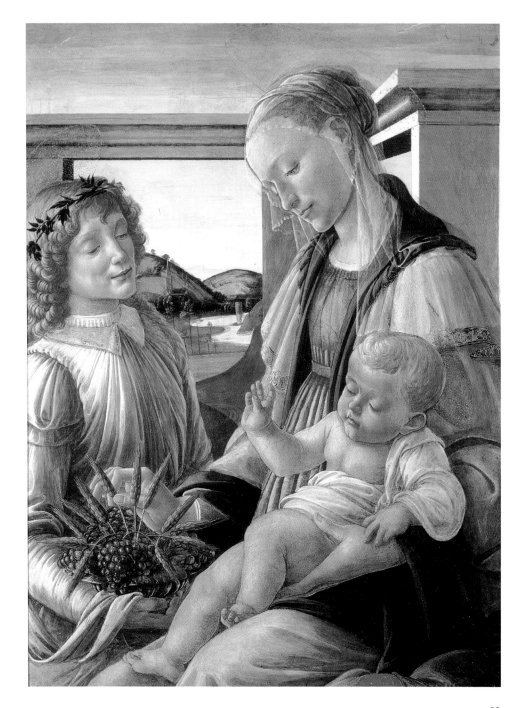

Portrait of Smeralda Bandinilli

c. 1475
Tempera on panel, 65.7 × 41 cm
London, Victoria and
Albert Museum

This painting once belonged to, among others, Dante Gabriel Rossetti, the English poet and painter, founder of the Pre-Raphaelite Brotherhood, confirming the fortune Botticelli's images enjoyed during the second half of the nineteenth century. Rossetti retouched the painting a bit. The painting's authenticity has not been unanimously accepted, but stylistic and typological comparisons of the female figures with the *Madonna of the Eucharist* and with the *Sant'Ambrogio Altarpiece* from the Galleria degli Uffizi have made it possible to situate the work among others painted by Botticelli in the early 1470s. The woman portrayed in the portrait was identified thanks to the writing still partially legible on the windowsill: it would be Esmeralda Donati, wife of Viviano Brandini and grandmother of the sculptor Baccio Bandinelli. The latter, however, assumed this last name only after 1530 and similar circumstances led to the retention of the apocryphal writing. The painting renews the typology of the Florentine portrait by inserting the figure within a complicated architectonic box of Nordic origin, which, with its cuts of light, make the person more natural and contributes to attracting the viewer's attention.

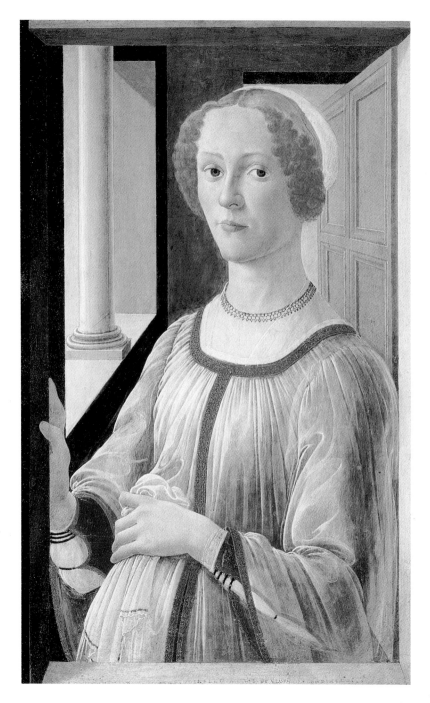

Portrait of a Man with the Medal
of Cosimo the Elder

1475
Tempera on panel,
57.5 × 44 cm
Florence, Galleria degli Uffizi

There has been much debate over the identity of this young man with his "melancholic" and sulky gaze. The medal held in his hands and presented to the viewer does not offer very useful information. It portrays Cosimo de' Medici when he had already been dubbed with the title of Pater Patriae (an epithet conferred upon him in 1465) leading to the retention of the identification of the person portrayed as possibly being Piero, the son of Cosimo. The man's apparent age, however, has led critics to exclude the hypothesis of this being a member of the Medici family and caused the attention to be shifted to the world of medal minters, considering the prominence given over to the object the man holds in his hands. After various proposals and exclusions, it was thus suggested that the figure could be Antonio Botticelli, the brother of Sandro, who worked as a goldsmith and, in 1475, as a medal minter for the Medici.

The comparison between his apparent age in the painting and his actual age at the time of the painting, however, are not compatible. The observation has been made that this man and Botticelli, who portrayed himself in the *Adoration of the Magi* in the Del Lama Chapel at the Uffizi, share pertinent features. Beyond identification efforts, the work is indebted to Flemish art, above all in the landscape in the background, and exhibits a technical quality and an analytical capacity that has reached full maturity.

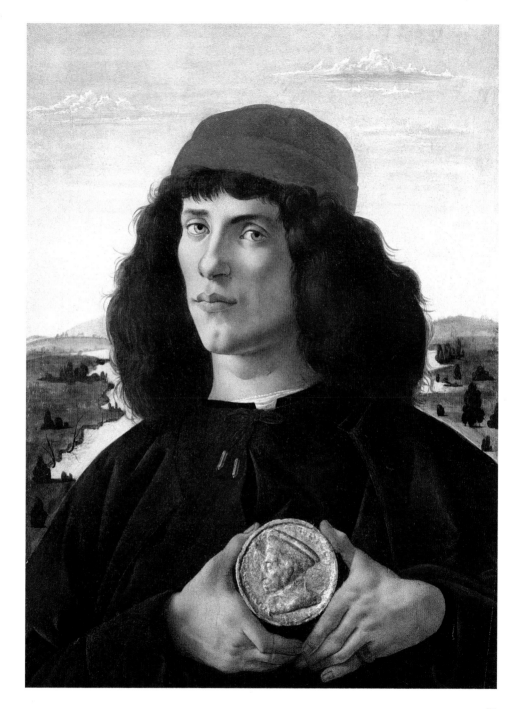

Adoration of the Magi

1475
Tempera on panel,
111 × 134 cm
Florence, Galleria degli Uffizi

The altarpiece was painted for the chapel of Guasparre Del Lama located in the entry to the church of Santa Maria Novella. It is known that the painting then became the property of the Medici since it is cited in the family's inventories. This is the third time that Botticelli portrays the theme of the Adoration. In the perfectly balanced composition figures are arranged in a gentle and articulated manner within the space; the vivid color and attention to detail (notice the refined gold accents on the clothing) do not disrupt the overall effect; the landscape has a Nordic and essential tone to it. This version of the subject from the New Testament, with figures portrayed extremely naturally, drew the admiration of Vasari.

The painting is also known for its problems with the identification of the figures: the oldest king next to the Christ child may be recognized as Cosimo the Elder, while the one who is kneeling and dressed in a red mantle may be recognized as his son, Piero il Gottoso (the gouty), who died in 1469. The third king to the right, intent on speaking with the prior, is identified as Giovanni (who died in 1461), the other son of Cosimo; the young man to the far left, with a red doublet leaning on his sword, is, according to some, Lorenzo the Magnificent, and according to others, Giuliano; next to him, Pico della Mirandola and Agnolo Poliziano; Giuliano (or Lorenzo) is the young man standing at the center of the group to the right and wearing black. Even the painting's patron would appear standing in the group on the right, with white hair. He is intent on pointing toward the viewer, while the young man cloaked in yellow, to the far right, would represent the painter. The presence of known persons recognizable by contemporaries in a work intended for a church may be interpreted as a sort of declaration of belonging and loyalty to a political faction on the behalf of its patron, and indirectly to the painter.

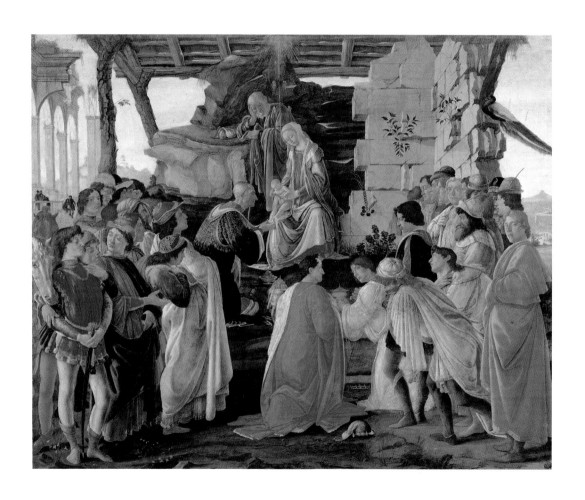

Nativity with the Infant Saint John

1476–1477
Detached wall painting,
200 × 300 cm
Florence, Santa Maria Novella

This detached fresco probably comes from the Lami or Del Lama chapel for which Botticelli also painted the altarpiece (*Adoration of the Magi*, Florence, Galleria degli Uffizi). Conservation efforts, and heavy repainting in particular, raised doubts among a few art historians regarding the painting's authenticity, however, it was confirmed following restoration in the 1980s.

Some critics have suggested the date of this work, in which a strong influence of Filippo Lippi may be recognized. It is clear that Botticelli borrowed Lippi's model for the scene with the same subject at the Duomo in Spoleto. The insertion of Saint John in the background, where his hasty gait seems to disturb the intimacy of the scene, is not very successful.

Portrait of Giuliano de' Medici

c. 1478
Tempera on panel,
54.5 × 36.5 cm
Milan, Crespi Collection

Until the late nineteenth century, this painting was belonged to the same collection as the *Portrait of Lorenzo the Magnificent* (the most recent known whereabouts of which was a Parisian collection), a work with a questionable background. This Milanese painting belongs to a group of three others (conserved in Berlin, Bergamo and Washington D.C.) with the same subject, facing right however. Critics have not been able to assess with any certainty which of the portraits served as the original model for the others. Unlike this painting, the others portray Giuliano with partly closed eyes and features rendered with accentuated rigidity in addition to presenting him facing in the opposite direction; meanwhile, in the version in Washington D.C. (National Gallery) he holds a turtledove resting on a dry branch. This detail alluding to death and the characteristics described above lead to the general belief that all the works were made after the tragic death of the subject in the Pazzi conspiracy (1478), while the Milanese version in which they are absent leads to the belief that it could be a portrait made while Giuliano was still alive. Giuliano de' Medici, younger brother of Lorenzo the Magnificent, is also recognizable thanks to the many commemorative medals that bear his image; he was killed by emissaries of the Pazzi family (banker-enemies of the Medici), while celebrating a mass at the Duomo in Florence. Giuliano and the events in his life are closely tied to those of Botticelli, who not only painted the facade of the Porta della Dogana at the Palazzo della Signoria with the portraits of the slayers after the latter were condemned, but also made the standard, now lost, for the Joust of 1475, won by Giuliano and also celebrated by Poliziano.

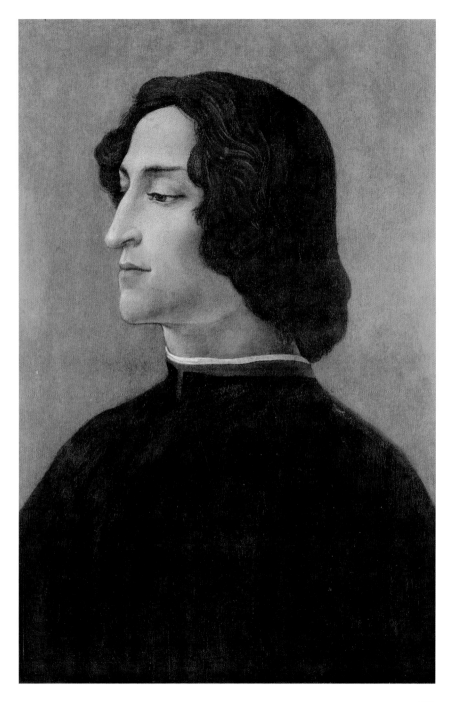

Saint Augustine

1480
Detached wall painting,
152 × 112 cm
Florence, Church of the
Ognissanti

According to art historians, the decision to represent Saint Augustine in a companion piece to Saint Jerome by Domenico Ghirlandaio, both of whom are traditionally shown devoted to study, should be researched in the acceptance, by the Umiliati to whom the church belonged, of Saint Benedict's rule, which recognized the great importance of study. Botticelli's saint suggests a deep meditative layer, and the painter's intention was to confer upon the image of the Father of the church that attitude of ardent concentration that, according to philosophical categories, should have qualified men of wisdom. Botticelli renders the saint with great spatial vigor within a study that is crowded with books, instruments and other furnishings. He is mindful of the lesson of Andrea del Castagno in the absolute plastic evidence and dominion of space derived from the cycle of Illustrious Men painted for the Villa Carducci in Legnaia (c. 1450).

The coat of arms in the center of the architrave at the top has been recognized as that of the Vespucci family, believed by some to be the same branch to which the father of Amerigo belonged. This detail makes the family the probable patron of the work. On the shelf cluttered with objects is a clock that marks the hour just after sunset, while the light in the painting has a daytime quality to it. The explanation of this contradiction should be looked for in an epistle, previously attributed to Augustine, in which the saint told that, at the time marked by the clock, he was invested with light and heard the voice of Jerome; only afterward did Augustine learn that the saint was dying. What is written on the left-hand page of the open book among the geometric figures is another matter entirely; it is a rhyming phrase whose subject is one unknown Friar Martin: "Dov'è Fra Martino? È scappato. E dov'è andato? È fuori della porta a Prato" (Where is Brother Martin? He's run away. And where did he go? Outside the city gate to Prato).

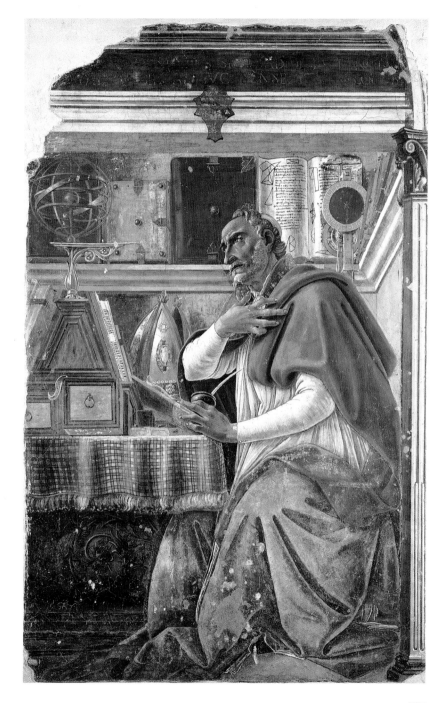

Madonna with Child
(Madonna with the Book)

1480–1481
Tempera on panel,
58 × 39.5 cm
Milan, Museo Poldi Pezzoli

The painting offers the same theme of the *Madonna of the Magnificat*, resolving it with great balance and sense of color, enhanced by the gold that is knowingly dosed. The painting has two emotional centers: the hands of the Virgin and child held in analogous positions—the right hands resting one upon the other and open on the book in a gesture evoking benediction, the left hand closed on the Christ child's lap—and the gazes that cross one another. Attention is given over to the details of the still life, such as the book of the *Horae beatae mariae*, the bowl holding cherries that alludes to Paradise and the box in the background.

The presence of nails and the crown of thorns should come as no surprise as it constitutes a highly diffused example of the premonition of the crucifixion of Jesus. This painting ran into an abundance of fortune over the centuries, precisely because of its simple devotional approach.

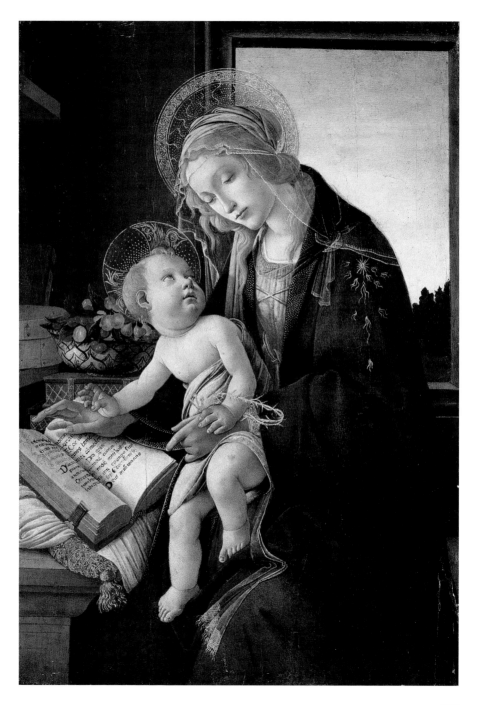

Annunciation
(San Martino alla Scala Annunciation)

1481
Detached wall painting,
243 × 555 cm
Florence, Galleria degli Uffizi

This painting once adorned a wall in the Ospedale di San Martino alla Scala in Florence, which also functioned a hospice for the plague-stricken. This purpose should be kept in mind as Florence was hit by the plague from 1478 and the painting's existence could be connected with the end of the epidemic. The painting was executed between April and May of 1481, as attested by a receipt for payment in the name of one Donato di Ser Francesco. The scene is in an architectural setting opening onto a courtyard and the composition is punctuated along its vertical lines by pilasters and pilaster strips painted with grisaille, horizontally by the divisions of the foreshortened paving. To the right is Mary, kneeling in the foreground; the perspectival box of the bedroom opens beyond her. To the left, the angel, motionless, yet vibrant in the air, behind whom may be seen a beautiful landscape recalling the *Hortus conclusus*, which traditionally alludes to Mary's virginity. The oblique position of the angel anticipates the analogous solution adopted for the spring winds Zephyr and Aura depicted in the Birth of Venus.

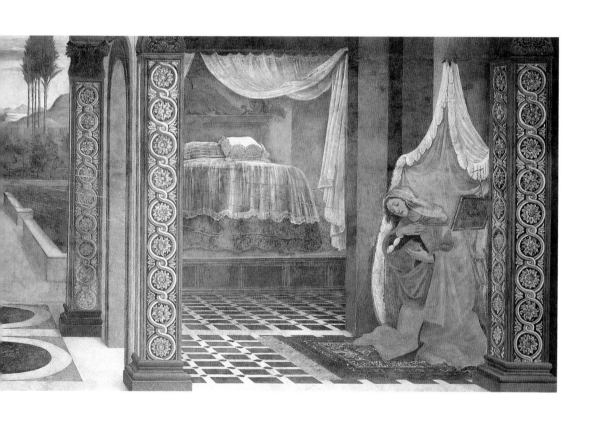

Madonna and Child with Five Angels
(Madonna of the Magnificat)

1481
Tempera on panel,
diameter 118 cm
Florence, Galleria degli Uffizi

The original location of this painting, which may be chronologically placed within the immediacy of the painter's Roman journey (1481), is unknown. The scene seems to take place alongside an architectonic oculus, of which the blocks of the stone masonry are visible at the top. The Virgin is being crowned by two angels and it is the inclination of her head that propels the circular rhythm of the composition, marked by the clasped hands of mother and child. The work takes its name from the biblical song that Mary is intent upon (or has just finished) writing with help from the hand of the infant Jesus. The motif of the pomegranate, a known reference to the resurrection of Christ, returns here.

The distribution of the figures seems to be a bit forced into the round form of the painting, in particular, the angel placed to the far left who holds the crown over Mary's head, just as a slight disproportion between the divine figures and those of the angels is evident. This may be explained through devotional reason or by the painter's conscious decision in his desire to test the possibilities for combining figures within the round format. Botticelli's training in Filippo Lippi's workshop is recognizable in the profusion of gold and precious details in the fabrics and veils. The work, one of Botticelli's most famous, had already become a topos, as the many replicas that have come down to us testify.

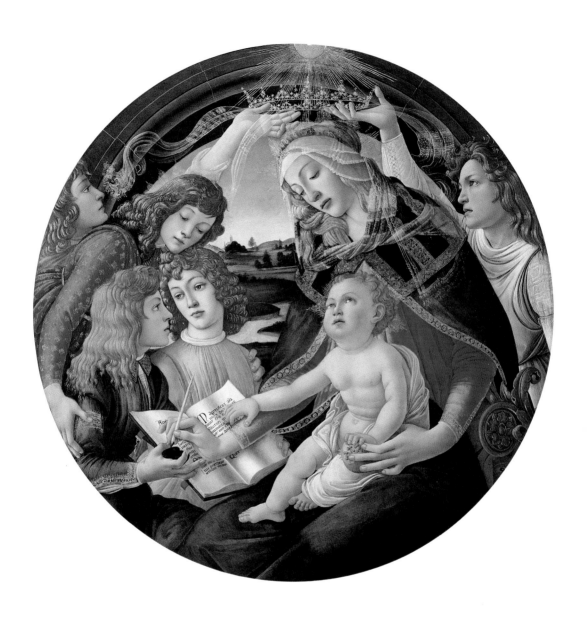

The Temptation of Christ

1481–1482
Wall painting,
345.5 × 555 cm
Vatican City, Sistine Chapel

This painting represents the temptations of Christ, which may be read across the temple's cornice. The scenes depict, from the top left, Christ being invited by the devil, shown in pilgrim's dress, to transform stone into bread. At the center, instead, Christ is seen on top of the temple being provoked by the demon to throw himself into the void. Finally, to the right, the devil, now undressed, throws himself into the void after Christ's refusal to dominate the world. On the left, in the lower register, Christ is comforted by the angels, while, at the center, a priest celebrates a sacrifice, prefiguring that of the Eucharist.

Here too, many of the persons depicted in the scene portray prelates and family of the pope, whose house is even referenced by the oak trees in the painting: to the left, for example, the young man shown in profile, getting up from his marble seat, is wearing a dark blue cloak decorated with golden oak leaves, the heraldic symbol of the pope's family. The feminine figure to the right holding the faggot of sticks on her head is of rare formal grace and anticipates that of the graces in *Allegory of Spring*, while the same cannot be said of the other woman who, in the background on the left, also carries things on her head and is a more common version of the theme.

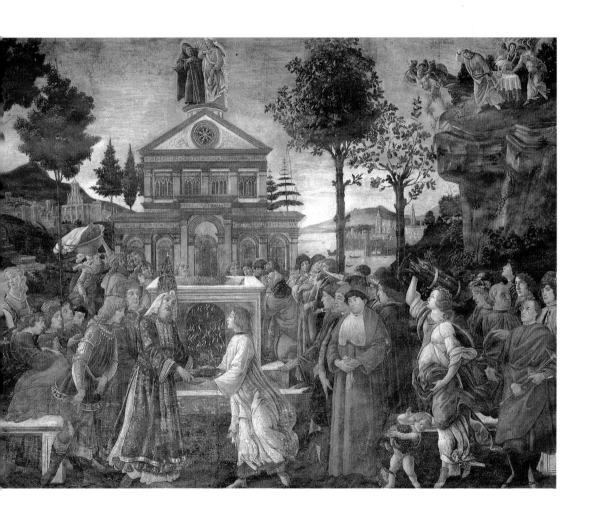

The Trials of Moses

1481–1482
Wall painting,
348.5 × 558 cm
Vatican City, Sistine Chapel

It is well-known that Pope Sixtus IV della Rovere commissioned various artists to produce wall paintings to decorate the Sistine Chapel. Convoked at the same time as Botticelli were Perugino, Domenico Ghirlandaio and Cosimo Rosselli. The pope himself provided the iconographic program, which centered on the prefigurations that tie together the Old and New Testaments. Botticelli painted the three stories as well as (in some cases his direct intervention is evident, while in others only the drawing is by his hand) the figures of eleven popes. In this fresco, Moses wears a yellow tunic and a green cloak and the episodes in which he is protagonist are arranged in separate planes easy to read. In the lower right, he kills the Egyptian who tormented the young Jew and he goes off into the desert with his back turned to us; in the center, Moses chases away the pastors who had attacked the daughters of Jethro and draws water from the well for them; at the top, Moses is intent upon removing his shoes (here Botticelli cites a statue from antiquity, the *Spinario*, who sits in the same position), before the burning bush. In the lower left, Moses leads his people toward the Promised Land. It is clear how the story unfolds and the figure of the patriarch guides the reading of the narration that is punctuated by portraits, by beautiful female forms that are typologically similar to the

three Graces, as is the case of the daughters of Jethro. The strong influence of Ghiberti's works, his Gates of Paradise in particular, is apparent in this work that borrows his compositions and the intersection of the oblique lines of the hills with the vertical ones of the trees.

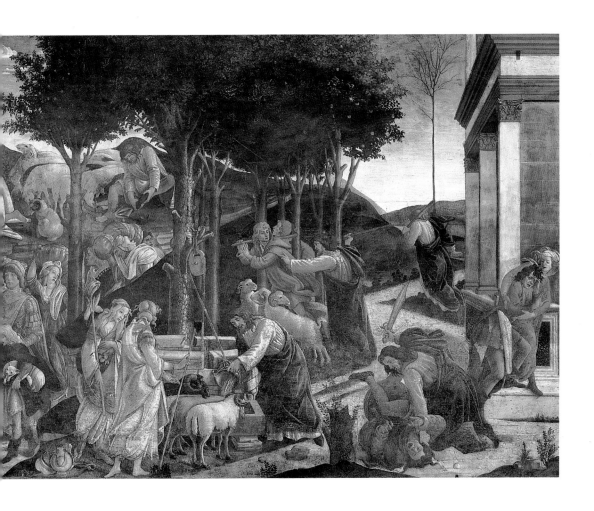

Punishment of Korah

1481–1482
Wall painting,
348.5 × 570 cm
Vatican City, Sistine Chapel

This painting, which should be read from right to left, depicts how those who rebelled against the authority of Moses, Aaron and other priests were punished. To the right, Joshua saves Moses from being stoned by the rebels. The background of this scene is a building that may probably be identified as Settizonio, which was still standing during Botticelli's lifetime. At center, against a backdrop of the Roman Arch of Costantine, faithfully reproduced except for the reliefs, Moses raises his wand and the divine fire dispels the rebel priests. Finally, the earth breaks open, swallowing the Levites, with the exception of the two innocent sons who are seen floating on a cloud. The clear spatial structure divided by the architectural structures, contrasts with the intense and dramatic movements of the figures. Considerable political meaning is given to the scene as it acts as a model presenting the punishments bestowed upon those who dared to rebel against the recognized authorities, Moses in the Old Testament and the church of Christ in the contemporary world. This concept is expressed clearly in the inscription above the barrel vault arch of the Arch of Constantine, in a kind of invective against anyone who usurps the honor to lead a people: *nisi vocatus a deo* (unless they are called upon by god). In this scene, as in the others, gold is used profusely to highlight the details of the story.

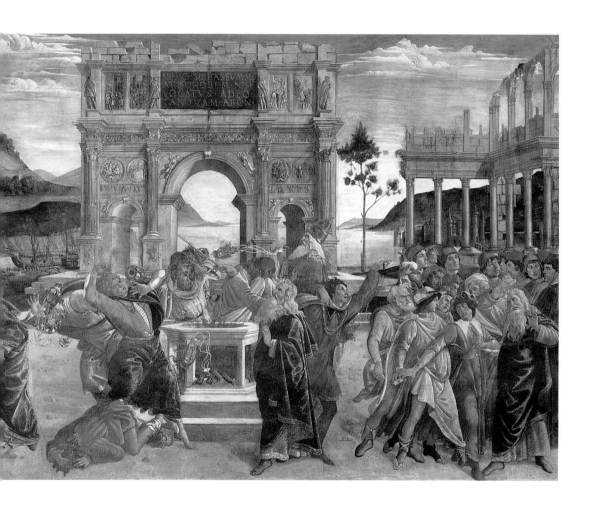

117

Allegory of Spring

1481–1482
Tempera on panel,
203 × 314 cm
Florence, Galleria degli Uffizi

This painting may be recognized among the titles cited in an inventory of 1499, in which it is remarked that it was hanging above a *lettuccio*, or little bed, in the room adjacent to the bedroom of Lorenzo di Pierfrancesco de' Medici in the family palace in Via Larga. There are many hypotheses that have been used to identify the reason for the commission, but none offered an exhaustive explanation. It has nonetheless been possible to identify some significant circumstances: one of the literary sources that seems to be connected to this work, in addition to Ovid's *Metamorphoses* and *Lucretius*, are the *Stanzas* by Poliziano.

In Poliziano's lines may be found references to the love that united Giuliano to Simonetta Cattaneo, which according to some should be understood more in a courtly-chivalrous key, than in reality, considering the fact that Simonetta was the spouse of Marco Vespucci. The connection with the Vespucci family appears, firstly, because of the very close relationships that tied the previous owner of the work to Giorgio Antonio Vespucci, one of his favorite preceptors, who was also connected to the Florentine cultural elite. Secondly, in relation to the marriage celebrated in 1482 between Lorenzo di Pierfrancesco and Semiramide Appiani, the niece/granddaughter of Simonetta Vespucci, which could constitute the occasion for which the work was painted.

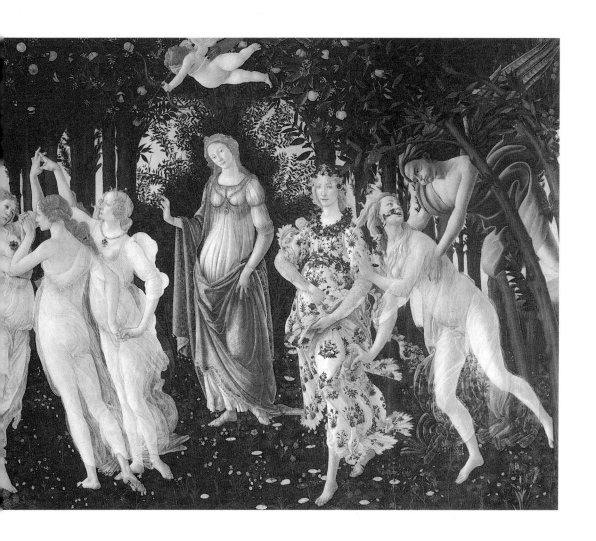

Pallas and the Centaur

1482–1483
Tempera on canvas,
207 × 148 cm
Florence, Galleria degli Uffizi

This painting was made for Lorenzo di Pierfrancesco de' Medici and is mentioned in the registers of his household; in the inventories compiled since the Seicento this painting is also associated with the *Birth of Venus* and *Allegory of Spring*. It was believed that the standard Vasari mentions that was made for the Joust of Giuliano de' Medici (1475)—the same one for which Poliziano wrote his Stanzas—could be recognized in this painting, but the iconographic references made this identification impossible. The female figure is dressed in a white gown that has a decorative motif consisting of three interwoven rings with a diamond, ascribable to the Medici family; olive branches create the wreath encircling the woman's head and they also twist down her arms and around her breasts. She carries a large shield on her back and holds a ceremonial halberd in her hand. She is shown holding the centaur, a monstrous creature half man and half horse, by the hair. His expression lies between a frown and sadness. Considering the powerful sentimentalism of his expression, the wild creature could be borrowed from antique models from the Hellenistic Age. The most convincing reading proposed (political-celebratory of the close alliance of Lorenzo with Naples or the pact with Innocent VIII, or generalized exaltation of the Medici family as patron of the arts) is one that relates the painting to the Neoplatonic circles of Careggi, giving it the allegorical significance of control exercised by reason and chastity over blind instinct, also suggesting a celebration for the wedding of Lorenzo di Pierfrancesco and Semiramide Appiani.

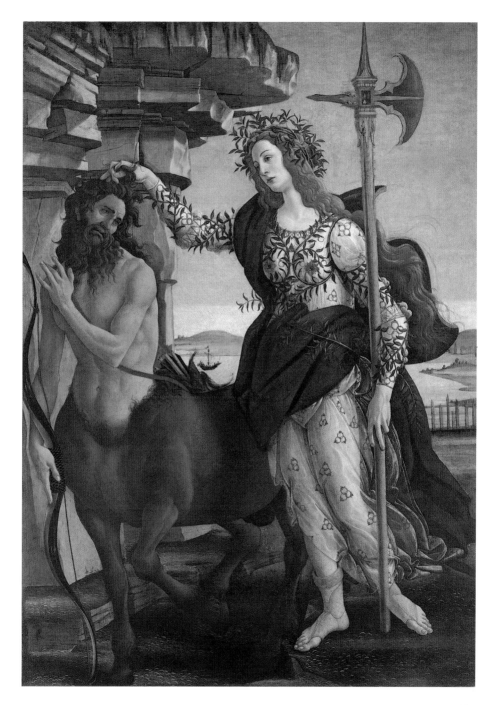

Nastagio degli Onesti I

1483
Tempera on panel,
83 × 138 cm
Madrid, Museo Nacional
del Prado

The story of Nastagio degli Onesti is faithful to the eighth novella of the fifth day in Giovanni Boccaccio's *Decameron*. The shape of the panels, which were probably a part of the wooden decoration of a room, together with their subject have led art historians to recognize them as paintings executed on the occasion of the wedding of Giannozzo Pucci with Lucrezia Bini, celebrated in 1483.

In this scene, Nastagio, on the left, wanders, saddened by his beloved's rejection; at the center, he battles the dogs that pursue and maul a young nude woman chased by a horseman. The painter chooses to tell the story through its crucial moments without any sense of continuity. The backdrop of trees offering a view of a seascape of serene completeness, refers to the city of Ravenna.

Nastagio degli Onesti II

1483

Tempera on panel,
83 × 138 cm
Madrid, Museo Nacional
del Prado

Nastagio is depicted shocked at the sight of the woman captured and cut open, whose entrails are thrown to the dogs. In the background, the terrible hunt begins again, because the horseman, who committed suicide for love, and the woman, who cruelly mocked the young man's love in life, are condemned to these sufferings by divine justice. Even in the enchanted, late-gothic, fable-like atmosphere, it is necessary to point out the affectation that tinges and substantiates the narrative climate, as is clear, for example, from the paling of the sky between the trees in the background. In this episode, too, critics have recognized the hand of Sandro Botticelli, particularly in the refined use of colors.

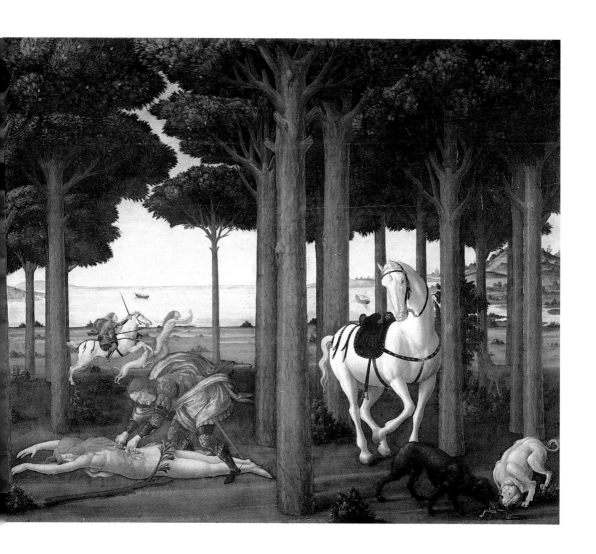

Nastagio degli Onesti III

1483
Tempera on panel,
83 × 138 cm
Madrid, Museo Nacional
del Prado

In light of the parallels between his own sentimental situation and the one in which the two tormented lovers find themselves, Nastagio organizes a banquet in the pine forest to which he invites his unyielding beloved and her parents. Here, they listen to the terrible epilogue of an unsuccessful love story similar to the one being lived. To the right, Nastagio meets the maidservant of his beloved and she tells how the young woman, deeply touched by what she saw, declares herself overcome. The coats of arms of the couple's families are visible in this scene as is that of the Medici, located in the center, which was intended to refer to the Bini and Pucci families, association with the faction near to the Medici. The idea of the enclosure within which the banquet takes place, the descriptive detail of the sumptuously laid table and the minute rendering of the physiognomic details imbue this painting with unique qualities.

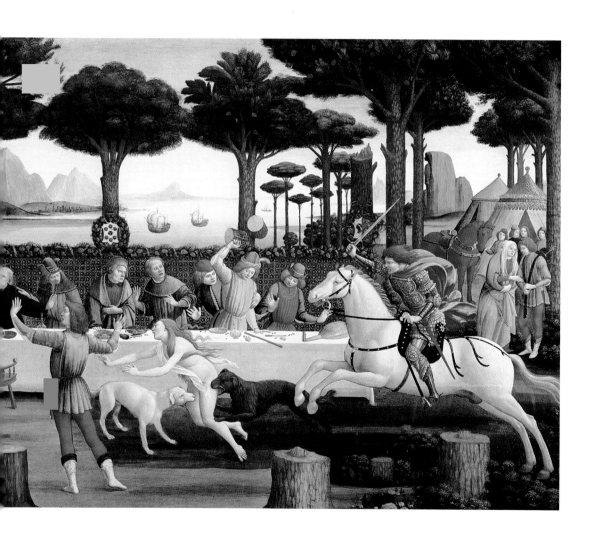

Nastagio degli Onesti IV

1483
Tempera on panel, 84 × 142 cm
Private collection

This scene depicts Nastagio's wedding banquet set within solemn classic porticoed architecture ending in a triumphal arch. The coats of arms displayed refer to the Pucci and Bini families. The disposition of the figures and the furnishings corresponds precisely to descriptions of nuptial banquets held in Florence at the time. The presence of such imposing architecture would be incomprehensible without the painter's experience in Rome for the decoration of the Sistine Chapel. The series of paintings has a double purpose to it: a didactic one, intended to counsel the young bride Lucrezia Bini on the power of love; and the apotropaic one, relative to the duration of happiness derived from wedlock. Unlike Boccaccio's novella, in the painting the social and political entreaties of the nuptials are highly relevant.

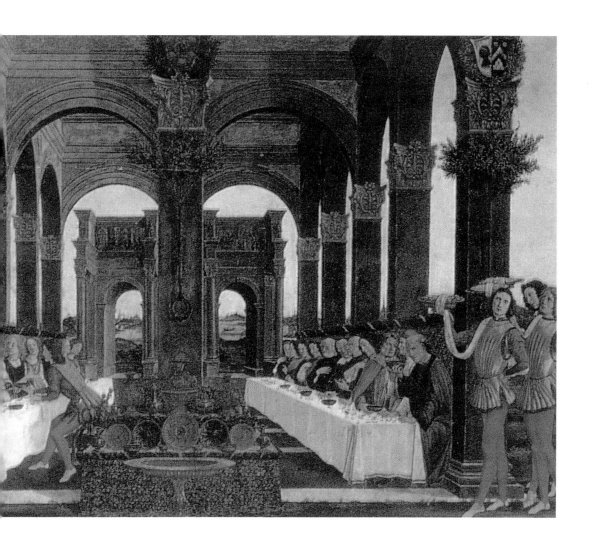

Venus and Mars

1483
Tempera on panel,
69 × 173 cm
London, National Gallery

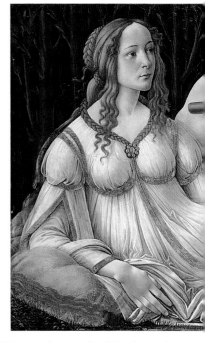

The scene shows Venus intent on contemplating her spouse, Mars, who is lost to sleep. Such iconography is drawn from the ancient Greek writer Luciano, and, in light of the painting's dimensions and shape, it is plausible that it was to be inserted within the fixed woodwork of a room. The presence of a bee nest behind Mars has led to the suggestion that it was made for a member of the Vespucci family. The painting was, in fact, also read as an allegory of matrimony, in which Love, personified by Venus, would have the power to tame even the bellicose spirit, personified by Mars. The composition is substantiated by the faultless opposition of the two figures: the fully dressed goddess with her hair all set, whose dress, falls softly in folds, espouses her body; the god, meanwhile, is nude and sculptural. Little satyrs play around the two lovers with Mars' weapons and armor, as Luciano tells us in the *Dialogues*. The positions of the two divinities could be derived from an antique sarcophagus upon which Bacchus and Arianna are depicted in the same positions. An iconographic reading in a Neoplatonic overtone interprets Venus as Humanitas, or the highest grade of human evolution, exercising control over the force of discord.

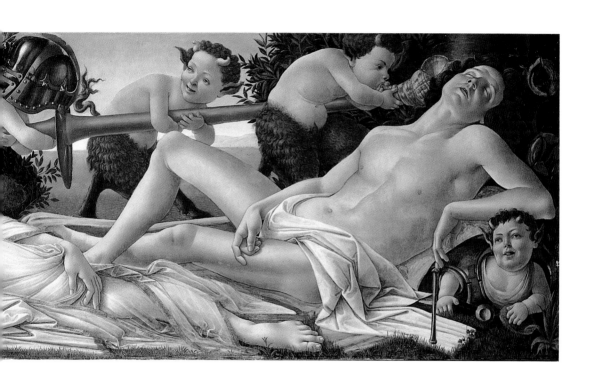

Villa Lemmi Cycle:
Venus and the Three Graces Presenting Gifts to a Young Woman

1483–1486 (?)
Detached wall paintings
transferred to canvas,
211 × 284 cm
Paris, Musée du Louvre

This painting belongs to a cycle that was once located in the villa at Chiasso Macerelli, owned by the Tornabuoni family between 1469 and 1541. The paintings were brought to light in 1873 by the removal of a layer of whitewash that covered them, and the attribution to Botticelli was made by Crowe and Cavalcaselle, who were among the first to see the works. The circumstances of the commission of the paintings and then their dating are disputed by art historians: in fact, some suggest that among the youths depicted in the cycle may be recognized Lorenzo, the son of Giovanni Tornabuoni, and Giovanna degli Albizi, who were married in 1486; according to others, the newlyweds should be identified as Matteo degli Albizi and Nanna Tornabuoni, whose nuptials were celebrated in 1483. The certainty of the identification of the families united by marriage may be derived from the presence in this cycle of works, upon their discovery, of the coats of arms that distinguish them. In the painting, a young woman receives gifts from Venus, the goddess of love, dressed similarly to the Venus depicted in the *Allegory of Spring* and accompanied by the Three Graces.

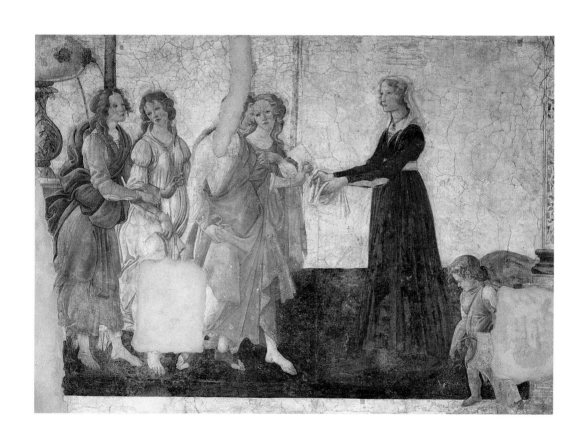

133

Birth of Venus

1484
Tempera on canvas,
184.5 × 285.5 cm
Florence, Galleria degli Uffizi

For this veritable Renaissance icon neither the precise date nor the occasion or patron for which it was made are known. The work has been variously dated, but it seems pertinent to date its execution after Botticelli's Roman sojourn. The literary sources Botticelli or, more properly, his patrons, used may be recognized in Ovid and, again, in Poliziano, to which may also be added the myth that in fifteenth-century Florence continued to encompass a painting with the same subject made by the Greek painter Apelle. At the center of the canvas, Venus stands on one half of a shell in the *Venus pudica* stance as she nears the beach; to the right, one of the Hours rushes to cover the goddess, holding out a mantle decorated with a floral motif. To the left, Zephyr and Aura blow together to push Venus ashore. The iconography was connected to the presence of Venere-Humanitas, which was so central to Neoplatonic philosophy.

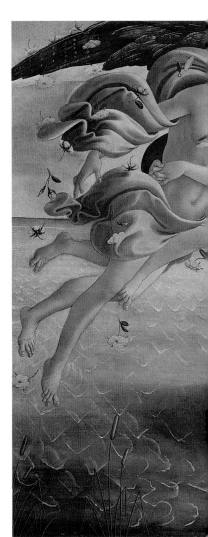

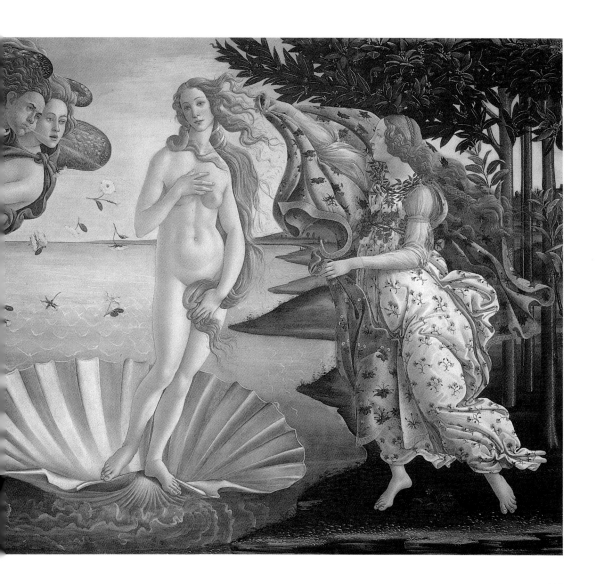

Virgin and Child with Four Angels and Six Saints (Catherine of Alexandria, Augustine, Barnabas, John the Baptist, Ignatius and Michael Archangel) (Saint Barnabas Altarpiece)

1487
Tempera on panel,
268 × 280 cm
Florence, Galleria degli Uffizi

Predella with
Lamentation for Christ
Tempera on panel, 21 × 41 cm
Florence, Galleria degli Uffizi

Made for the Florentine church from which it borrows its name, this painting was probably commissioned from Botticelli by the Guild of Doctors and Apothecaries, the patrons of the church. The altarpiece underwent major interventions that led to the loss of the frame and three stories from the predella, in addition to changes in its dimensions. Here Botticelli offers a taste of his mature compositional talent for inserting figures within a complex architectural context that is dense with references to antiquity, as may be observed in the decorative details. Even the colors are richer, while Saint John shows evidence of references to contemporary sculpture. On the step to the throne are inscribed the first verses of the prayer that Dante has delivered to Saint Bernard in the last canto of the *Divine Comedy*, which the painter illustrated over a long period in his life.

The panel depicting the *Lamentation for Christ* is one of the seven that originally made up the predella; the eighteenth-century interventions that also involved the latter caused three panels to be lost. The panel with the *Lamentation for Christ* was located at the center of the others and was visually connected to the angels, in the altarpiece, holding the symbols of the Passion.

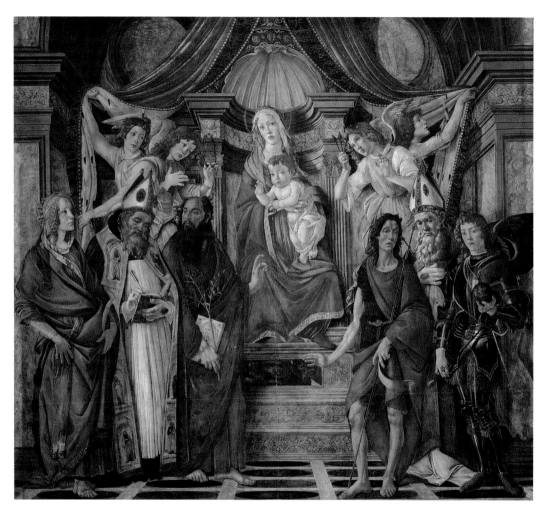

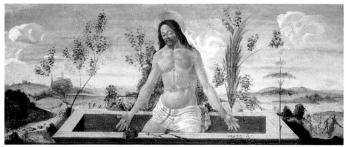

Virgin and Child with Six Angels
(Madonna of the Pomegranate)

1487

Tempera on panel,
diameter 143.5 cm
Florence, Galleria degli Uffizi

A wood frame carved with gilded lilies on a deep blue background surrounds this painting. It is believed to be original because it is cited in an old inventory; a document, now lost, connected the painting to the commission of the Magistrati di Camera, which had their seat in Palazzo Vecchio. The presence of lilies and the color blue in the frame confirm both the ancient location and the commission of the work. When compared with the other Madonna on a round canvas (*Madonna of the Magnificat*, Florence, Galleria degli Uffizi), the great mastery of space achieved by the painter is made clear by the firm placement of the angels around Mary, the varied positions and expression of the figures, who are characterized by sculpturesque physiognomies, are only hinted at in the other painting. Mary's face is similar to that of Venus. Again the typically Marian attributes of roses and lilies are present, while the pomegranate held in the Christ child's hand alludes to the resurrection.

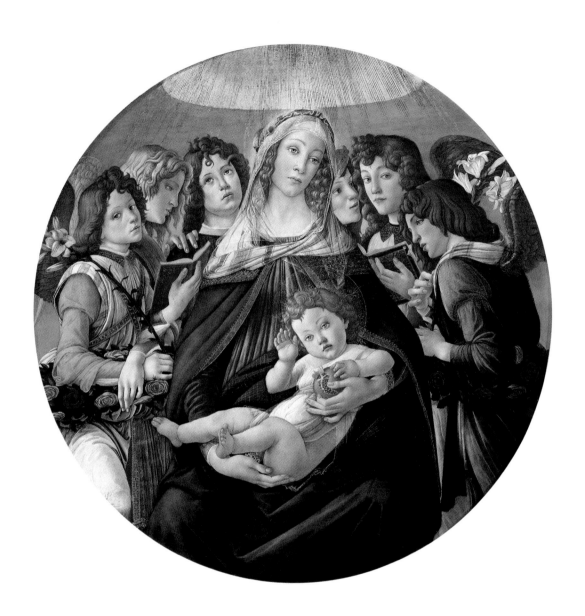

Coronation of the Virgin with Saints John the Evangelist, Augustine, Jerome and Eligius (San Marco Altarpiece)

1488–1490
Tempera on panel,
378 × 258 cm
Florence, Galleria degli Uffizi

This work was commissioned by the Guild of Silk Weavers, the patron of the chapel of Saint Eligius, the patron saint of goldsmiths. The altarpiece introduces an innovation that is key to the structure of the devotional altarpiece, which anticipates a compositional scheme that would become common only in the sixteenth century. The scene is divided into two separate registers: the lower one, with the saints and the upper one in which the miraculous event takes place. Although it occurs in the cultural climate of the late Quattrocento, at a time when the sensation of insecurity and crises of civil bravery pushed the most culturally and spiritually endowed toward a rediscovery of religious values tied to consolidated tradition and its reassuring world. This explains the figure of Saint John the Evangelist, aroused by mystic ardor, and the apparition immersed in the gold of the background and the pure colors of the upper half. The predella (not shown here) is divided into five compartments with the *Annunciation* at the center as a theological narrative of what happens in the painting and, on the sides, depictions of episodes from the lives of the saints.

141

Annunciation
(Cestello Annunciation)

1489
Tempera on panel,
240 × 235 cm
Florence, Galleria degli Uffizi

This painting still has its original gilded frame, consisting of a pair of pilaster strips on each side, decorated with candelabras, an architrave with a palm motif alternating with angels' heads and, beneath, a base divided into fields in which the *Lamentation for Christ* stands out in the center and the coat of arms of the Guardi del Cane family stand out on either side. In fact, the altarpiece was commissioned from the painter by Benedetto Guardi, an important public official registered in the Moneychangers Guild, which had acquired the patronage of an altar at the church of the monks of Cestello located in the San Frediano neighborhood in Oltrarno, whence the work's name. The scene takes place in a room with stark architecture, in which the gray wall in the background is pierced by a doorway framed by molding in *pietra serena*, which comes from the best layers of stone, and flooring of square tiles foreshortened in perspective. The third protagonist, a riverscape, makes a powerful entry into the sacred scene through the doorway, with the architecture of bridges and castles and their unmistakable Nordic flavor. This work reveals echoes of contemporary Florentine sculpture (for example, Donatello's *Annunciation* at Santa Croce for Mary's position) and, when it is compared with another work by Botticelli of the same subject at San Martino alla Scala (1481; Florence, Galleria degli Uffizi), the artist's course of development becomes more evident. It is clearly headed toward a simplification of forms through the ever more limited recourse to narrative-descriptive details and interest in the monumental rendering of space. The *Lamentation for Christ* in the predella is similar to that in the predella of the *Saint Barnabas Altarpiece* (Florence, Galleria degli Uffizi).

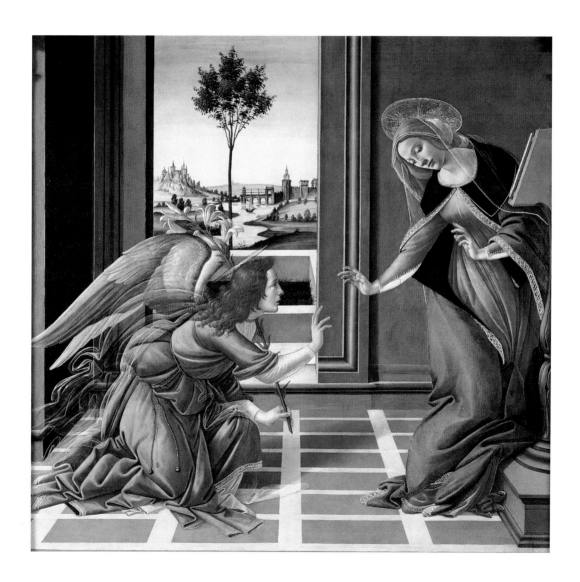

Annunciation

c. 1490
Tempera on panel,
49.5 × 58.5 cm
Glasgow, Glasgow Art Gallery

On the back of this small panel is written that it comes from the Florentine church of San Barnaba, where it would have occupied a relatively significant position, considering the dimensions. The scene takes place within a solemn architectural setting that almost surpasses the figures of the protagonists in the event and this "aggrandizement", despite the painting's dimensions, differentiates it from other small paintings with identical subjects that are chronologically close, one of which is in the Lehman Collection at the Metropolitan Museum of Art in New York, the other in the Hyde Collection at Glenn Falls, New York. Considered an early work by most critics due to the presence of stylistic modes originating in Verrocchio, Van Marle attributed it to circa 1490.

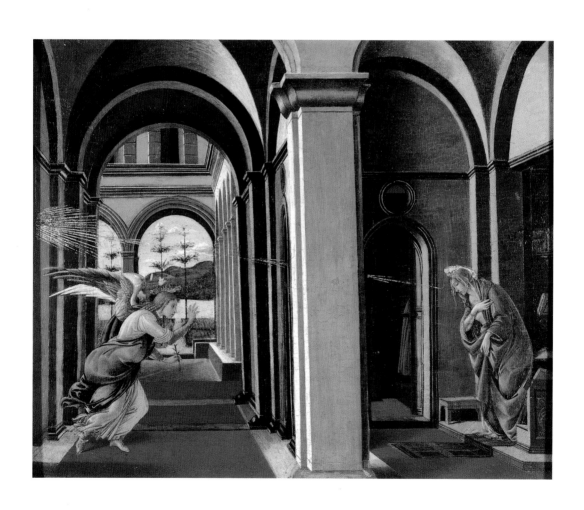

Annunciation

1490–1493
Tempera on panel,
23.9 × 36.5 cm
New York, The Metropolitan
Museum of Art

There is no consensual attribution of this work to Botticelli. In fact, while critics recognize the success of its layout, they highlight its concise technique and weak execution. These stylistic details must, on the one hand, be placed within the context of Botticelli's late production—it is almost a "compact edition"—on the other, explained by the panel's dimensions.

Starting in the 1490s, the painter's workshop produced many works in small dimensions to satisfy the most common devotional needs of the patronage. The work is close to those with identical subjects at the Glasgow Art Gallery and at Glenn Falls, New York.

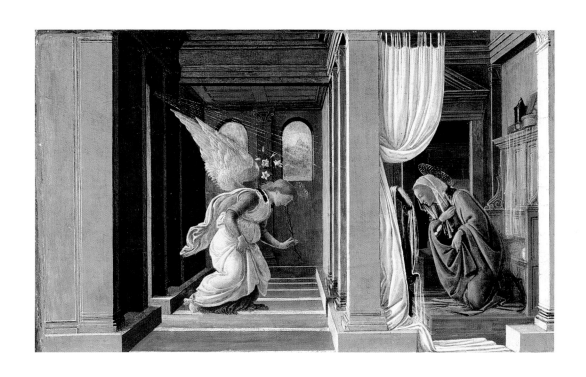

Saint Augustine in the Cell

1490–1495
Tempera on panel,
41 × 27 cm
Florence, Galleria degli Uffizi

This work was probably originally intended for the priory of the convent of the Augustinian hermits of Santo Spirito in Florence as the saint's double cloak—that of a hermit and that of a bishop—would suggest. Here, Botticelli offers us a more traditional version of the saint that is only apparently more domestic, a long way off from the heroic mysticism depicted at Ognissanti.

Here, Augustine is intent upon writing (the inclusion of shredded and crumpled pieces of paper on the floor is beautiful) within an architectural setting that is simple in its refinement and probably echoes Giuliano da Sangallo's interiors, with its rigorous layout, with the medallion bearing a depiction of the Virgin and child in an allusion to the saint's writings on Marian themes. The medallions depicting busts of Roman emperors, which may be seen to each side of the opening to the cell, might refer to the period during which the saint lived, when the Roman Empire was divided between emperors Arcadius and Honorius.

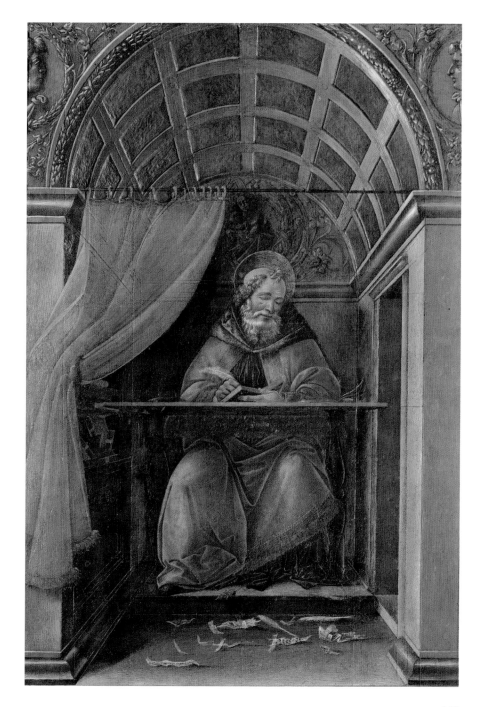

Lamentation over the Dead Christ, with Saints Jerome, Paul and Peter

1492
Tempera on panel,
140 × 207 cm
Munich, Alte Pinakothek

This work comes from the Florentine church of San Paolino, where the prior was Agnolo Poliziano. This origin is confirmed by the presence of Saint Paul, who is accompanied by saints Peter and Jerome. In the nineteenth century, this work was acquired by Prince Ludwig of Bavaria, after which it went to the state. The entire composition centers on the central group of Mary swooning with Christ's body abandoned to death, his head held by the pious woman on the viewer's right. The pair of saints on the left (Saint Jerome with a nude torso holding the stone with which he beat his breast, and behind him Saint Paul holding a sword, his usual attribute), slightly inclined, is unbalanced with respect to Saint Peter standing upright, alone on the right. At the center of the grotto may be seen the edge of the stone sepulcher, a detail that is missing in the later Milanese version of the theme. The beauty of the heads of Christ and the woman and the stationary Saint Peter is noteworthy, especially for their lighting.

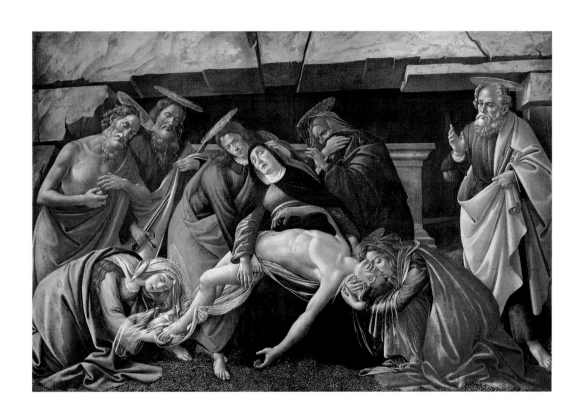

151

Virgin and Child with Three Angels
(Madonna of the Pavillion)

c. 1493
Tempera on panel,
diameter 65 cm
Milan, Pinacoteca Ambrosiana

This round painting is recognized as the one mentioned by Vasari in the *camera del priore*, or prior's room, at the convent of Santa Maria degli Angeli in Florence. If we accept this identification, the work could be dated to sometime between the years 1486 and 1498, when Guido di Lorenzo d'Antonio, friend of Lorenzo the Magnificent, was the prior. After the death of the latter, the prior was imprisoned by Savonarola's followers. Here, Mary is depicted as the *Maria Lactans*, offering her breast to the Christ child who is held by an angel. The scene takes place on a balcony, out of doors, and the work takes its name from the sumptuous baldachin whose curtains are being drawn by angels. Stylistically, the painting is close to the *San Marco Altarpiece* (1488–1490; Florence, Galleria degli Uffizi), while the information on its patronage suggests a date of about 1493. The painting bears all the symbols tied to Marian devotion, from the *Hortus conclusus*, or enclosed garden alluding to virginity, to the lily, symbol of purity. It also depicts a decrease in proportions that unites different figures, which is characteristic of Botticelli's later works.

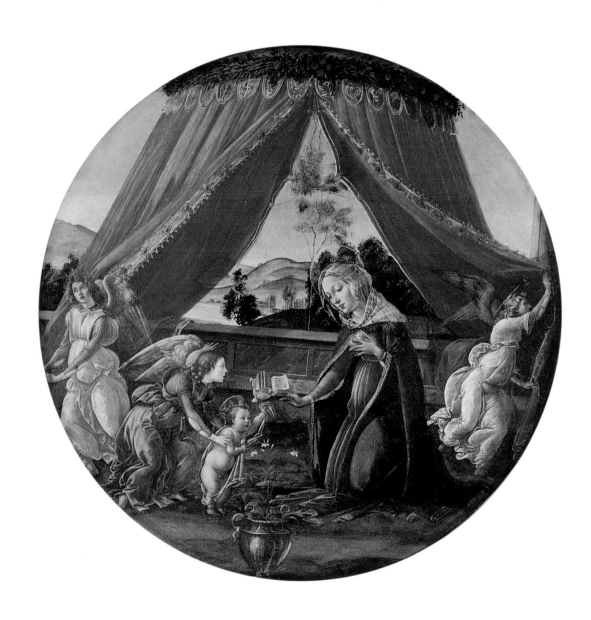

Virgin and Child and Infant Saint John

c. 1490–1495
Tempera on canvas,
134 × 92 cm
Florence, Galleria Palatina,
Palazzo Pitti

The origin of this painting, characterized by an intense senti-mental effusion between the figures, is unknown. Mary appears almost disproportionate and compressed within the painting's format; the young Saint John embraces Jesus, who, like Mary, possesses a downcast gaze, in the mute consideration of his own death. The descriptive details are extremely limited (there is the grassy carpet that almost looks more like a tapestry rather than true fields of flowers as in the 1480s), the only apparent concession made lies in the curtain of roses to the left, behind the Madonna. The bush of flowers, traditional attributes of Mary, the mystic rose, adds a tone that is easy to understand in appearance only. Stylistically close to the *Lamentations*, in this work too may be seen once again the two heads close together, which confer a tone of pathos upon the painting. A similar version of this work exists that is at the Barber Institute of Birmingham.

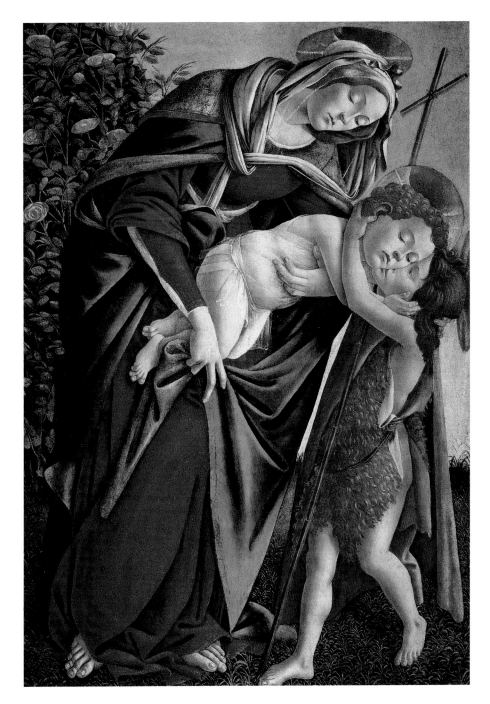

Lamentation over the Dead Christ

1495
Tempera on panel,
107 × 71 cm
Milan, Museo Poldi Pezzoli

According to some art historians this work was commissioned by Donato di Antonio Cioli, an illuminator of codices for the Florentine church of Santa Maria Maggiore, which was probably the first location of the work. The structure of the composition is built on a pyramidal layout, through the close contiguity of the figures to one another, and it contemporaneously evokes the shape of a cross, which culminates in Joseph of Arimathaea, depicted showing the nails and the crown of thorns. The sentimentalism is pronounced but realistic, and it is expressed both through desperate gestures (that of the woman with her head covered or the face of Joseph), and through the curves described by the bodies, which carve out the space with their weight. The scene, lacking in minute detail, constitutes an example of that intense, shared consideration of the sacred themes that occupied the last part of the painter's life; the very close vantage point forces the viewer into the scene.

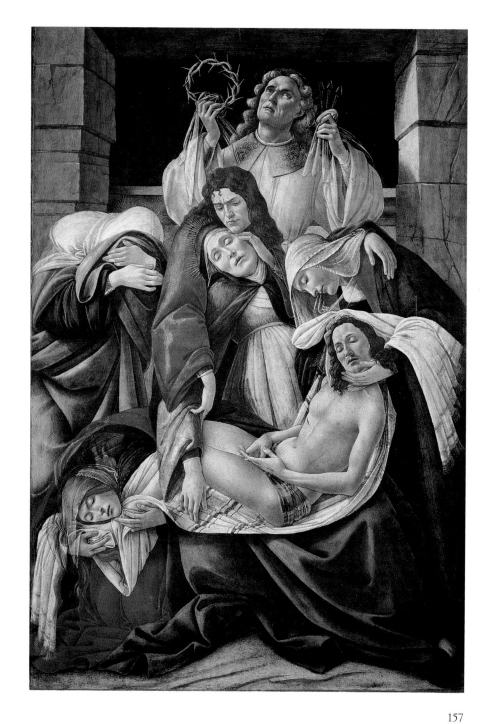

The Calumny of Appelles

1495
Tempera on panel,
62 × 91 cm
Florence, Galleria degli Uffizi

This painting comes from the house of the Segni, an important Florentine family. The allegorical scene refers to a painting, now lost, by Apelles, the most famous painter in antiquity who lived in the fourth century B.C. He painted an allegory of the Calumny as an exemplum of the false accusations suffered. The painting is described for us by Luciano and also by Leon Battista Alberti. Botticelli uses these sources and creates, despite the work's small dimensions, a painting laid out according to a grandiose architecture, dense, with reliefs and classical references. The scene is read from the right, where, seated upon a throne may be seen King Midas together with two feminine figures (Suspicion and Ignorance), who whisper into his ass's ears. Standing before the king, dressed in rags is Malice, who squeezes the wrist of Calumny, who is indifferent to what is happening; Calumny drags her victim—a livid, nude man who joins his hands as he pleads for help—by the hair. The figures of Envy and Fraud dress Calumny's hair; to the left of this central group, a cloaked old woman personifies Penitence and turns toward Truth, who is nude and raises her arm. The mobility of the color and light, brightened by touches of gold enliven the scene. The profusion of statues and low reliefs that represent classical divinities and heroes do not simply set the scene within a context, but also appear, through their distance and imperturbability, to mark Sandro's definitive detachment from the style they represent.

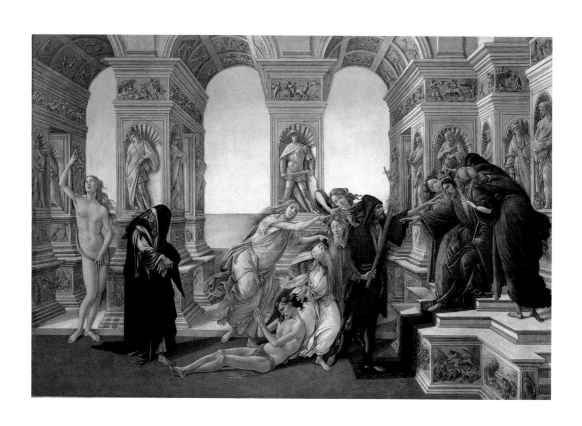

The Sermon on the Mount

1498–1500
Tempera on panel,
53 × 35 cm
Granada, Museo de los Reyes
Católicos, Capilla Real

This work, together with the *Mystic Crucifixion* (Cambridge, Mass., Fogg Art Museum) and the *Mystic Nativity* (London, National Gallery), marks the painter's last phase and shows just how much the climate of great incertitude, onto which the preachings of Savonarola were grafted, affected Botticelli's contemporaries. Here the painter's language approaches an extreme synthesis in which must be highlighted the conscious refusal of the use of perspective to outline a degree of simple composition with immediate devotional impact.

The incongruous spatial relationship between Christ and the trees in the distance on the ledge he is kneeling on must be noted. Likewise, the physical rendering of the apostles tends toward anatomical simplifications that are leagues away from the virtuosity that Botticelli had accustomed us to in the 1470s and '80s. The position and simplicity of the disciple on the left even quotes the Saint Joseph in the lunette at Santa Maria Novella. Although simplified, the landscape is quite detailed, such as the fence that seems almost out of place because of the hyperreality of its rendering.

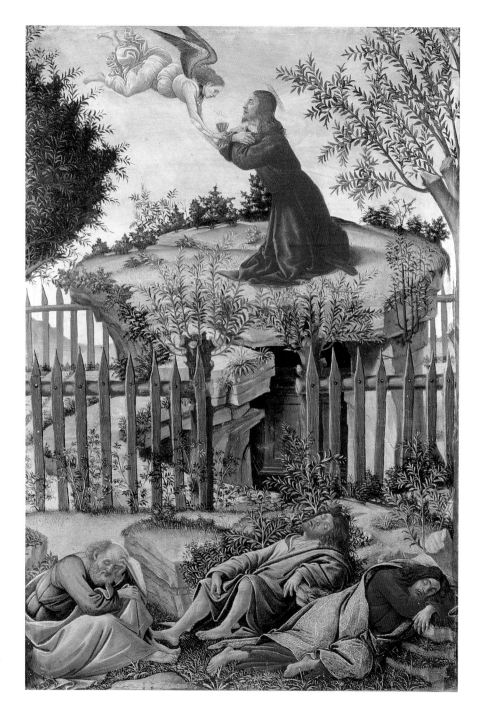

Adoration of the Magi

1500
Tempera (?) on panel,
107.5 × 173 cm
Florence, Galleria degli Uffizi

There has never been any doubt as to the authenticity of this work that has come down to us incomplete and in fairly precarious condition, thanks to the interventions that took place after the artist's original creation. This painting is very crowded and we see an extreme simplification of the landscape and naturalistic elements that is in tune with how the mature Botticelli's language was developing. The abstract scenery together with the placement of the central group against the dark background of the rock have led to a connection of this work to Leonardo da Vinci. The thronging and agitation of the figures make the painting a kind of spiritual testament, a voluntary interruption impressed by the painter on the parable of his own life and career.

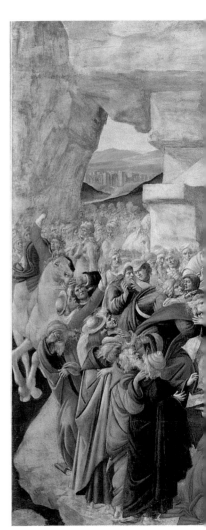

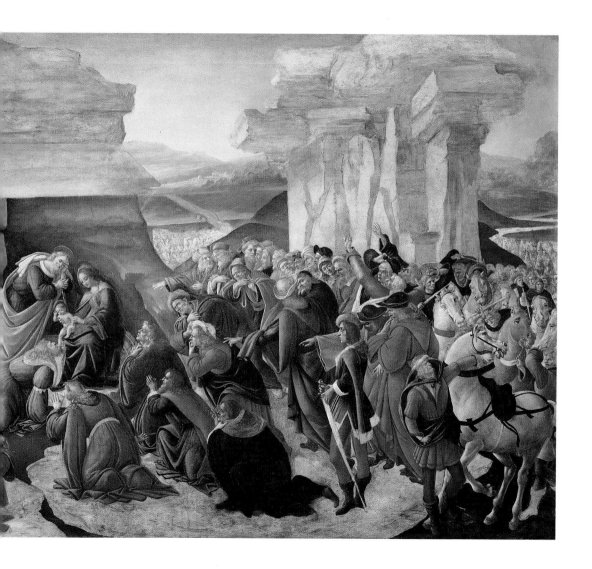

The Story of Lucretia

1500–1504
Tempera (?) on panel,
80 × 130 cm
Boston, Isabella Stewart
Gardner Museum

This painting, like the *Story of Virginia* (Bergamo, Accademia Carrara), was probably intended to complete the wood furnishings fixed to the walls of a home, known as the *spalliera*, at the time. According to some, the home was that of Guido Antonio Vespucci, who acquired a house in 1499. The story, taken from the ancient historians Livio and Valerio Massimo, tells of the events in the life of Lucretia, wife of Collatinus, who is attacked by Sextus, the son of Tarquinus the Proud, who rapes her; after the violence, the heroine whose virtue is upheld by her father and husband, then takes the dagger and kills herself. At the center of the scene lies the woman's cadaver and Brutus, standing at the base of a marble column supporting a statue of David, calls the soldiers to join in a

revolt that transforms the monarchy into a republic. Here, the architecture plays a fundamental role: the triumphal arch recalls the one painted in the *Punishment of Korah*, but here it becomes a backdrop, while the edifices on either side of the painting evoke the atmosphere of fifteenth-century Florence. These references to the contemporary city could mark the will to institute a comparison between the events recounted in the painting and those that actually occurred in Florence. One theme in particular is the abuse of violence, seen both as a means of power and a possibility to redeem one's honor.

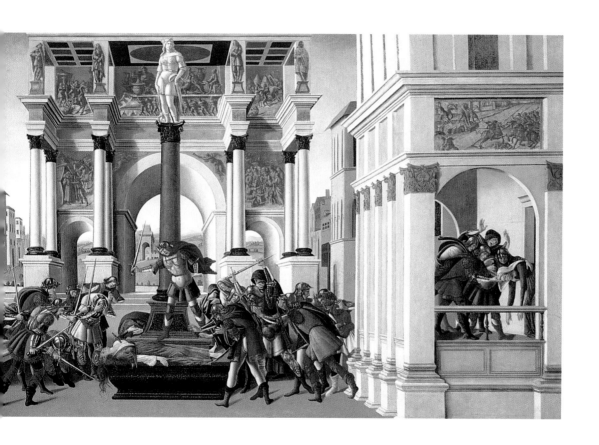

Story of Virginia

1500–1504
Tempera on panel,
86 × 165 cm
Bergamo, Accademia Carrara

Vasari refers to the stories set into a *spalliera*, or the wooden furnishings fixed to the walls of a room, in the house of the Vespucci. Critics identify them with the *Story of Lucretia*, conserved in Boston, and the *Story of Virginia*. The occasion for their painting would be the nuptials of Giovanni Vespucci and Namicina di Benedetto Merli (1500). In fact, the two episodes told by the paintings are considered examples of matrimonial loyalty. Some art historians have also hinted at the possibility of interpreting them as being painted in defense of liberty, in opposition to Medici power, but this hypothesis conflicts with the possibility of their belonging to the Vespucci, who had close ties with the Medici. The scene should be read from left to right: Virginia, in the company of the other women, is assaulted by Marcus Claudius, who wants her to give in to Appius Claudius. When she refuses, she is brought before court presided over by the same Appius Claudius, who declares her his slave. The woman's father and husband appeal for clemency in vain. Finally her father kills her to preserve her honor and then escapes. The architecture refers to examples from classical and Florentine antiquity; the painting's intimate character gives way to the excitement with which the figures, which the colors make vibrant, move.

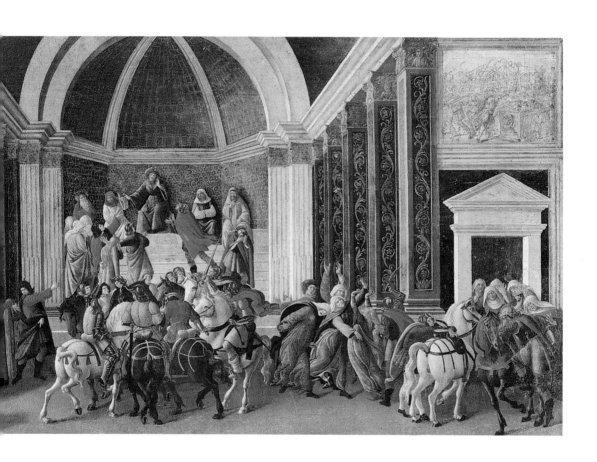

Story of Saint Zanobius, Last Miracle and Death

1500–1505
Tempera on panel,
66 × 182 cm
Dresden, Gemäldegalerie
Alte Meister

This panel is part of a series that includes three other paintings that today are divided up among different museums (two conserved in London, at the National Gallery and one at the Metropolitan Museum of Art in New York). They probably constituted part of a piece of domestic furniture. They depict the story of Florence's saint and bishop who lived in the fourth century, but toward whom great devotion perdured at the time of Botticelli through the biographies that continued to be published. In fact, some comparisons may be made between the painted narration and the one written by the Florentine priest Clemente Mazza, which was printed in 1487 and 1496. It is not known who commissioned the work, either an individual or a city institution, although a connection with the patron of the saint's biography, Filippo di Zanobi de' Girolami —the saint's presumed descendent—or with the Compagnia di San Zanobi, has been hypothesized. There has never been any doubt as to the authenticity of the painting, on the other hand, the quality of the painting is very high, both in terms of composition and its architectural layout and color. In the scene, which should be read from left to right, the protagonists are the deacons Eugenio and Crescenzio, who intercede with the saint through prayer; to the left a child is run over by a cart; he is then delivered to the deacons who beg for a miracle; finally the child is returned to his mother, saved. To the far right, the death of the saint.

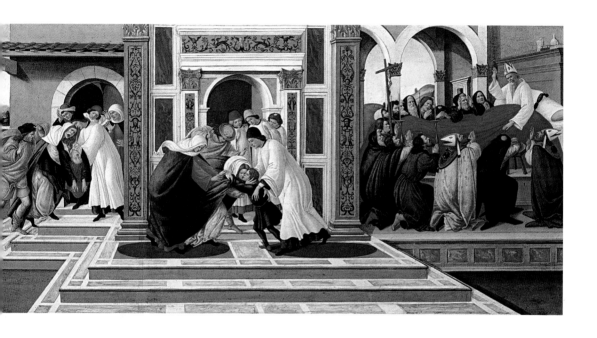

Mystic Nativity

1501

Tempera on panel,
108.5 × 75 cm
London, National Gallery
Signed and dated

This is the only work signed and dated within the long inscrip-
tion in Greek at the top of the panel. The text is truly obscure
and the translation could be understood as "This painting, at the
end of the year 1500, in the troubles of Italy, I Alessandro, in the
half-time after the time, according to the eleventh [chapter] of Saint
John, in the second woe of the Apocalypse, during the release of the
Devil for three-and-a-half years; then he shall be bound in the twelfth,
[chapter] and we will see [him buried] as in this painting." The
inscription has been variously interpreted, in particular in the refer-
ence to the "troubles of Italy," which according to some refers to
the situation that followed the death of Lorenzo the Magnificent,
or to the French invasion or, even to the expansionistic aims of
Cesare Borgia. The mention of the Apocalypse seems as though it
ought to be connected to Florence's difficult moment and to the omen
of new misadventures that could have befallen the city. In this
manner of apocalyptic visionary perspective may be depicted a refer-
ence to Savonarola's preachings. This could explain the archaic
tones of the composition or the presence of the three angelic figures
on the roof of the hut, suggesting the friar's preachings about the
Nativity, in which the adoring Virgin is accompanied by three young
girls personifying Grace, Truth and Justice. The same allegorical
value may be traced back to the different proportions used for the
devils and for the angels being embraced by men, by which Botticelli
most likely intended to suggest that the time had come to return to
the simple values of faith.

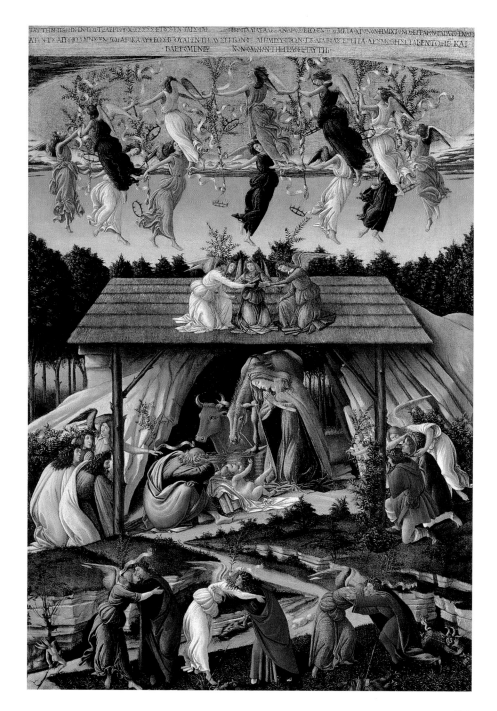

Appendix

Chronological Table

	The Life of Botticelli	Historical and Artistic Events
1445	Alessandro, known as Sandro, Botticelli is born in Florence, in the Ognissanti neighborhood. The son of Mariano di Vanni d'Amedeo Filipepi, leather tanner, and Smeralda, his wife. He was the last of four sons.	Beato Angelico completes the frescoes in the convent of San Marco, begun in 1439.
1447	In a *portata al catasto*, or tax declaration, the father declared his two-year-old son Alessandro.	The Florentines fight off the military actions of Alfonso I, king of Naples.
1458	Mariano Filepepi declares four sons to the *catasto*, including Antonio, goldsmith and goldbeater, and the thirteen-year-old Sandro who was "not in the best of health." Vasari maintains that at that time the boy was the student of a "goldsmith […] called Botticello"; the latter may have been his brother Antonio.	Pope Callisto III dies; he is succeeded by Enea Silvio Piccolomini under the name Pius II. Alfonso I dies; Ferdinand I succeeds him to the throne of Naples. Construction of the Pitti Palace begins.
1460	Mariano Filipepi withdrew from the profession.	
1464	Sandro joins the workshop of Filippo Lippi in Prato.	Filippo Lippi finishes the frescoes at the cathedral in Prato.
1467	Sandro returns to Florence and goes to Verrocchio's workshop.	Filippo Lippi begins the frescoes at the cathedral in Spoleto.
1469		Piero de' Medici dies; he is succeeded by his son Lorenzo.
1470	He works at home and lives with his family. According to the *Ricordanze* (Memoirs) of Benedetto Dei, he had his own workshop.	*Baptism of Christ* by Andrea del Verrocchio; Leonardo and, perhaps Botticell, participated in the work.
1472	He joins Saint Luke's Guild.	
1477	According to many art historians, he painted the *Allegory of Spring* in this year or the following year for Lorenzo di Pierfrancesco de' Medici.	Revolt of Ludovico il Moro in Genoa. Giovannino de' Dolci and Baccio Pontelli build the Sistine Chapel. Mohammed II invades the Venetian dominions until Isonzo and the Tagliamento rivers.
1478	He frescoes the portraits of the conspirators Jacopo, Francesco and Renato de' Pazzi and of the archbishop Salviati on the Porta della Dogana. The paintings were removed on November 14, 1494.	The Pazzi Conspiracy in Florence: Giuliano de' Medici is assassinated; Lorenzo remains in power, but is excommunicated by Sixtus IV, who lays Florence under an interdict.

	The Life of Botticelli	Historical and Artistic Events
1481	A declaration from Mariano Filipepi mentions his son Sandro in his home, together with other family members. In Rome he paints a fresco in the Sistine Chapel for a commission from Sixtus IV.	Truce in the war that had broken out two years earlier between Florence and Rome. Decoration of the Sistine Chapel in Rome (Perugino, Ghirlandaio, Botticelli, Cosimo Rosselli and others).
1482	In February Mariano Filipepi dies.	Completion of the decoration of the Sistine Chapel in Rome. First sojourn of Gerolamo Savonarola in Florence that would last until 1488.
1483	Botticelli paints the *Birth of Venus*r.	Louis XI, king of France dies; Charles VIII succeeds him to the throne.
1490		Savonarola's second Florentine sojourn, which would be drawn out until 1498.
1491		Pope Innocent VIII dies; Alexander VI succeeds him. Savonarola is prior of the convent of San Marco.
1492		Lorenzo the Magnificent dies; he is succeeded by Piero de' Medici. Savonarola writes the *Trionfo della croce (Triumph of the Cross)*.
1493	His brother Giovanni dies. His brother Simone returns from Naples and writes a *cronaca*, or account, of current events in Florence and Italy about these years proving himself an ardent follower of Savonarola.	
1494		Ludovico il Moro is elected duke of Milan. The fall of Charles VIII in Italy. Piero de' Medici is driven from Florence; Charles VIII enters Florence.
1497		May 13, Savonarola is excommunicated.
1498		May 23, Savonarola dies at the stake.
1510	Botticelli dies May 17. He is buried in the church of Ognissanti.	Luther sojourns in Rome. Death of Giorgione.

Geographical Locations of the Paintings
(in public collections)

Italy

Story of Virginia
Tempera on panel,
86 x 165 cm
Bergamo, Accademia
Carrara
1500–1504

*Madonna and Child
(Madonna della Loggia)*
Tempera on panel,
72 x 50 cm
Florence, Galleria degli Uffizi
1467

*Madonna and Child
(Madonna of the
Rosengarden),*
Tempera on panel,
124 x 64 cm
Florence, Galleria degli Uffizi
1469–1470

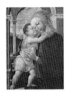

Fortitude
Tempera on panel,
167 x 87 cm
Florence, Galleria degli Uffizi
1470

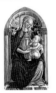

*Stories of Judith
Judith's Return to Bethulia*
Tempera on panel,
31 x 24 cm
Florence, Galleria degli Uffizi
1470–1472

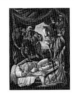

*Stories of Judith
Discovery of the Body
of Holofernes*
Tempera on panel,
31 x 25 cm
Florence, Galleria degli Uffizi
1470–1472

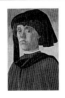

Portrait of a Young Man
Tempera on panel,
51 x 33.7 cm
Florence, Galleria Palatina,
Palazzo Pitti
c. 1470

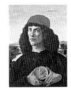

*Portrait of a Man with the
Medal of Cosimo the Elder*
Tempera on panel,
57.5 x 44 cm
Florence, Galleria degli Uffizi
1475

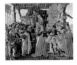

Adoration of the Magi
Tempera on panel,
111 x 134 cm
Florence, Galleria degli Uffizi
1475

*Nativity with the Infant
Saint John*
Detached wall painting,
200 x 300 cm
Florence, Santa Maria
Novella
1476–1477

Italy

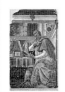

Saint Augustine
Detached wall painting,
152 x 112 cm
Florence, Church of the
Ognissanti
1480

Madonna and Child with
Five Angels
(Madonna of the Magnificat)
Tempera on panel,
diameter 118 cm
Florence, Galleria degli Uffizi
1481

Annunciation
(San Martino alla Scala
Annunciation)
Detached wall painting,
243 x 555 cm
Florence, Galleria degli Uffizi
1481

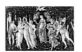

Allegory of Spring
Tempera on panel,
203 x 314 cm
Florence, Galleria degli Uffizi
1481–1482

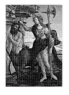

Pallas and the Centaur
Tempera on canvas,
207 x 148 cm
Florence, Galleria degli Uffizi
1482–1483

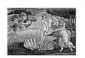

Birth of Venus
Tempera on canvas,
184.5 x 285.5 cm
Florence, Galleria degli Uffizi
1484

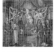

Virgin and Child with Four Angels
and Six Saints (Saint Barnabas
Altarpiece), Tempera on panel,
268 x 280 cm
Predella with Lamentation for
Christ, Tempera on panel, 21 x 41
cm, Florence, Galleria degli Uffizi, 1487

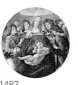

Virgin and Child with
Six Angels (Madonna
of the Pomegranate)
Tempera on panel,
diameter 143.5 cm
Florence, Galleria degli Uffizi
1487

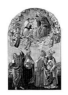

Coronation of the Virgin
with Saints
(San Marco Altarpiece)
Tempera on panel,
378 x 258 cm
Florence, Galleria degli Uffizi
1488–1490

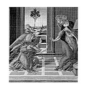

Annunciation
(Cestello Annunciation)
Tempera on panel,
240 x 235 cm
Florence, Galleria degli Uffizi
1489

Italy

Saint Augustine in the Cell
Tempera on panel,
41 x 27 cm
Florence, Galleria degli Uffizi
1490–1495

Virgin and Child with the Infant Saint John
Tempera on canvas,
134 x 92 cm
Florence, Galleria Palatina,
Palazzo Pitti
c. 1490–1495

The Calumny of Appelles
Tempera on panel,
62 x 91 cm
Florence, Galleria degli Uffizi
1495

Adoration of the Magi
Tempera (?) on panel,
107.5 x 173 cm
Florence, Galleria degli Uffizi
1500

*Madonna with Child
(Madonna with the Book)*
Tempera on panel,
58 x 39.5 cm
Milan, Museo Poldi Pezzoli
1480–1481

*Virgin and Child with
Three Angels
(Madonna of the Pavillion)*
Tempera on panel,
diameter 65 cm
Milan, Pinacoteca Ambrosiana
c. 1493

*Lamentation over the
Dead Christ*
Tempera on panel,
107 x 71 cm
Milan, Museo Poldi Pezzoli
1495

*Madonna and Child with
Two Angels*
Tempera on panel,
100 x 71 cm
Naples, Galleria Nazionale
di Capodimonte
1469–1470

Vatican City

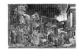

The Trials of Moses
Wall painting,
348.5 x 558 cm
Sistine Chapel
1481–1482

The Temptation of Christ
Wall painting,
345.5 x 555 cm
Sistine Chapel
1481–1482

Vatican City	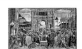	*Punishment of Korah* Wall painting, 348.5 x 570 cm Sistine Chapel 1481–1482	

France	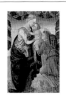	*Madonna and Child* *with Angel* Tempera on panel, 110 x 70 cm Ajaccio, Musée Fesch after 1465	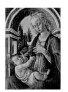 *Madonna and Child* Tempera on panel, 71.6 x 51 cm Avignon, Musée du Petit Palais, *c.* 1467
	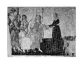	*Villa Lemmi Cycle: Venus and* *the Three Graces Presenting* *Gifts to a Young Woman* Detached wall paintings, 211 x 284 cm Paris, Musée du Louvre 1483–1486 (?)	

Germany	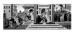	*Story of Saint Zanobius,* *Last Miracle and Death* Tempera on panel, 66 x 182 cm Dresden, Gemäldegalerie Alte Meister 1500–1505	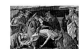 *Lamentation over the Dead* *Christ, with Saints Jerome,* *Paul and Peter* Tempera on panel, 140 x 207 cm Munich, Alte Pinakothek 1492

Great Britain	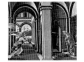	*Annunciation* Tempera on panel, 49.5 x 58.5 cm Glasgow, Glasgow Art Gallery *c.* 1490	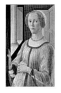 *Portrait of Smeralda Bandinilli* Tempera on panel 65.7 x 41 cm London, Victoria and Albert Museum *c.* 1475

Great Britain		*Venus and Mars* Tempera on panel, 69 x 173 cm London, National Gallery 1483		*Mystic Nativity* Tempera on panel, 108.5 x 75 cm London, National Gallery 1501

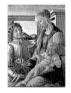

Great Britain

Venus and Mars
Tempera on panel,
69 x 173 cm
London, National Gallery
1483

Mystic Nativity
Tempera on panel,
108.5 x 75 cm
London, National Gallery
1501

Spain

The Sermon on the Mount
Tempera on panel,
53 x 35 cm
Granada, Museo de los
Reyes Católicos,
Capilla Real
1498–1500

Nastagio degli Onesti I
Tempera on panel,
83 x 138 cm
Madrid, Museo Nacional
del Prado
1483

Nastagio degli Onesti II
Tempera on panel,
83 x 138 cm
Madrid, Museo Nacional
del Prado,
1483

Nastagio degli Onesti III
Tempera on panel,
83 x 138 cm
Madrid, Museo Nacional
del Prado
1483

Unites States

*Madonna and Child with an
Angel (Madonna of the
Eucharist),* Tempera on panel,
85 x 64.5 cm
Boston, Isabella Stewart
Gardner Museum
1470–1472

The Story of Lucretia
Tempera (?) on panel,
80 x 130 cm
Boston, Isabella Stewart
Gardner Museum,
1500–1504

*Mary Magdalene Ascending
to Heaven, and Her Last
Communion*
Tempera on panel, 18 x 42 cm
Philadelphia, Philadelphia
Museum of Art, The Johnson
Collection
c. 1470

Annunciation
Tempera on panel,
23.9 x 36.5 cm
New York, The Metropolitan
Museum of Art
1490–1493

Writings

LIFE OF SANDRO BOTTICELLI
FLORENTINE PAINTER, c. 1445–1510

In the life of the elder Lorenzo de' Medici, Lorenzo the Magnificent, truly a golden age for men of talent, there flourished an artist called Alessandro (which we shorten to Sandro), whose second name, for reasons we shall see later, was Botticelli. He was the son of a Florentine, Mariano Filipepi, who brought him up very conscientiously and had him instructed in all those things usually taught to young children before they are apprenticed. However, although he easily mastered all that he wanted to, the boy refused to settle down or be satisfied with reading, writing, and arithmetic; and finally, exasperated by his son's restless mind, his father apprenticed him as a goldsmith to a close companion of his own called Botticelli, who was a very competent craftsman. Now at that time there was a very close connexion—almost a constant intercourse—between the goldsmiths and the painters, and so Sandro, who was a very agile-minded young man and who had already become absorbed by the arts of design, became entranced by painting and determined to devote himself to it. He told his father about his ambition, and Mariano, seeing the way his mind was inclined, took him to Fra Filippo of the Carmine, a great painter of that time, and, as Sandro himself wished, placed him with Fra Filippo to study painting.

Botticelli threw all his energies into his work, following and imitating his master so well that Fra Filippo grew very fond of him and taught him to such good effect that very soon his skill was greater than anyone would have anticipated. While still a young man Botticelli painted in the Mercanzia of Florence, among the pictures of virtues executed by Antonio and Piero Pollaiuolo, a figure representing Fortitude. In Santo Spirito in Florence, for the Bardi Chapel, he did a panel picture, very carefully painted and beautifully finished, with some olive trees and palms depicted with loving care. He also painted a panel picture for the Convertite Convent and another for the nuns of Santa Barnaba. In the church of Ognissanti, in the gallery by the door leading to the choir, he painted for the Vespucci family a fresco of St Augustine, over which he took very great pains in an attempt to surpass all his contemporaries but especially Domenico Ghirlandaio, who had painted a St Jerome on the other side. This work was very favorably received, for Botticelli succeeded in expressing in the head of the saint that air of profound meditation and subtle perception characteristic of men of wisdom who ponder continuously on difficult and elevated matters. As I said in my *Life* of Ghirlandaio, this year (1564) this painting of Botticelli's was removed safe and sound from its original position.

Because of the credit and reputation he acquired through his St Augustine, Botticelli was commissioned by the Guild of Porta Santa Maria to do a panel picture for San Marco showing the Coronation of Our Lady surrounded by a choir of angels, which he designed and executed very competently. He also carried out many works in the house of the Medici for Lorenzo the Magnificent, notably a life-size Pallas on a shield wreathed with fiery branches, and at St Sebastian. And in Santa Maria Maggiore at Florence, beside the chapel of the Panciatichi, there is a very beautiful Pietà with little figures.

For various houses in Florence Botticelli painted a number of round pictures, including many female nudes, of which there are still two extant at Castello, Duke Cosimo's villa, one

showing the Birth of Venus, with her Cupids, being wafted to land by the winds and zephyrs, and the other Venus as a symbol of spring, being adorned with flowers by the Graces; all this work was executed with exquisite grace. In the Via de' Servi around a room in Giovanni Vespucci's house (which now belongs to Piero Salvati) Botticelli painted several pictures showing many beautiful and very vivacious figures, which were enclosed in walnut paneling and ornamentation. In the house of the Pucci he illustrated—with various little figures in four paintings of considerable charm and beauty—Boccaccio's story about Nastagio degli Onesto,[1] and he also did a circular picture of the Epiphany. For a chapel belonging to the monks of Cestello he did a panel picture of the Annunciation. Then for the San Piero Maggiore, by the side door, he did a panel for Matteo Palmieri, with a vast number of figures, showing the Assumption of Our Lady and the circles of heaven, the patriarchs, prophets and apostles, the evangelists, martyrs, confessors, doctors, virgins, and the hierarchy of angels, all taken from a drawing given to him by Matteo, a very learned and talented man. Botticelli painted this work with exquisite care and assurance, introducing the portraits of Matteo and his wife kneeling at the foot. Although the painting is so great that it should have silenced envy, it provoked some malevolent critics to allege, not being able to fault it on any other score, that Matteo and Sandro had fallen into the sin of heresy. Whether this was so or not I am not the one to say; it is enough for me that the figures which Sandro painted in this picture are admirable for the care lavished on them, and the manner in which he has shown the circle of the heavens, introducing foreshortenings and intervals between his variously composed groups of angels and other figures, and executed the whole work with a fine sense of design.

At that time Sandro was commissioned to paint a small panel, with figures a foot and a half in length, which was placed in Santa Maria Novella between two doors in the principal façade on the left as one goes in by the center door. The subject is the Adoration of the Magi, and the picture is remarkable for the emotion shown by the elderly man as he kisses the foot of Our Lord with wonderful tenderness and conveys his sense of relief at having come to the end of his long journey. This figure, the first of the kings, is a portrait of the elder Cosimo de' Medici, and it is the most convincing and natural of all the surviving portraits. The second king (a portrait of Giuliano de' Medici, the father of Pope Clement VII) is shown doing reverence with utterly absorbed devotion as he offers his gift to the Child. The third, also on his knees, is shown gratefully adoring the Child whom he acknowledges as the true Messiah; and this is Cosimo's son, Giovanni. The beauty of the heads that Sandro painted in this picture defies description: they are shown in various poses, some full-face, some in profile, some in three-quarters, some looking down, with a great variety of expressions and attitudes in the figures of young and old, and with all those imaginative details that demonstrate the artist's complete mastery of his craft. For Botticelli clearly distinguished the retinues belonging to each of the three kings, producing in the complete work a marvelous painting which today amazes every artist by its colouring, its design, and its composition.

His Adoration of the Magi made Botticelli so famous, both in Florence and elsewhere, that Pope Sixtus IV, having finished the building of the chapel for his palace at Rome and wanting to have it painted, decided that he should be put in charge of the work. So Botticelli himself painted the following scenes for the chapel: Christ tempted by the devil; Moses slaying the

Egyptian and accepting drink from the daughters of Jethro the Midianite; fire falling from heaven on the sacrifice of the sons of Aaron; and several portraits of canonized popes in the niches above. Having won even greater fame and reputation among the many competitors who worked with him, artists from Florence and elsewhere, Botticelli was generously paid by the Pope; but living in his usual haphazard fashion he spent and squandered all he earned during his stay in Rome. Then, when he had finished and unveiled the work he had been commissioned, he immediately returned to Florence where, being a man of inquiring mind, he completed and printed a commentary on a part of Dante, illustrating the *Inferno*. He wasted a great deal of time on this, neglecting his work and thoroughly disrupting his life. He also printed many of his other drawings, but the results were inferior because the plates were badly engraved; the best was the Triumph of the Faith of Fra Girolamo Savonarola of Ferrara. Botticelli was a follower of Savonarola's, and this was why he gave up painting and then fell into considerable distress as he had no other source of income. None the less, he remained an obstinate member of the sect, becoming one of the *piagnoni*, the snivelers, as they were called then, and abandoning his work; so finally, as an old man, he found himself so poor that if Lorenzo de' Medici (for whom he had among other things some work at the little hospital at Volterra) and then his friends and other worthy men who loved him for his talent had not come to his assistance, he would have almost died of hunger.

One of Sandro's paintings, a very highly regarded work to be found in San Francesco outside the Porta a San Miniato, is a Madonna in a circular picture with some angels, all life-size.

He was a very good-humoured man and much given to playing jokes on his pupils and friends. For example, the story goes that one of his pupils, called Biagio, painted a circular picture exactly like the one of Botticelli's mentioned above, and that Sandro sold it for him to one of the citizens for six gold florins; then he found Biagio and told him:

"I've finally sold this picture of yours. So now you must hang it up high this evening so that it looks better, and then tomorrow morning go along and find the man who bought it so that you can show it to him properly displayed in a good light, and then he'll give you your money."

"Oh, you've done marvellously," said Biagio, who then went along to the shop, hung his picture at a good height, and left. In the meantime, Sandro and another of his pupils, Jacopo, had made several paper hats (like the ones the citizens wore) which they stuck with white wax over the heads of the eight angels that surrounded the Madonna in his picture. Then, when the morning came, Biagio arrived with the citizen who had bought the painting (and who had been let into the joke). They went into the shop, where Biagio looked up and saw his Madonna seated not in the midst of angels but in the middle of the councillors of Florence, all wearing their paper hats! He was just about to roar out in anger and make excuses when he noticed that the man he was with had said nothing at all, and was in fact starting to praise the picture [...] so Biagio kept quiet himself. And at length he went home with him and was given his six florins, as the price agreed by Botticelli. Then he went back to the shop, a moment or two after Sandro and Jacopo had removed those paper hats, and he found that the angels he had painted were angels after all and was so stupefied that he was at a loss for words. Eventually he turned to Sandro and said:

"Sir, I don't know if I'm dreaming or if this is reality, but when I was here earlier those

angels were wearing red hats, and now they're not. What's the meaning of it?"

"You've taken leave of your senses," said Sandro. "All that money has gone to your head. If what you say were true, do you think he'd have bought your picture?"

"That's so," said Biagio, "He didn't say a word. But all the same it struck me as very strange."

Then all the other apprentices flocked around him and convinced him that he had had some kind of giddy spell.

Another time, a cloth-weaver moved into the house next to Sandro's and set up no less than eight looms which when they were working not only deafened poor Sandro with the noise of the treadles and the movement of the frames but also shook his whole house, the walls of which were no stronger than they should be. What with one thing and the other, he couldn't work or even stay in his house. Several times he begged his neighbour to do something about the nuisance, but the weaver retorted that in his own home he could and would do just what he liked. Finally, Sandro grew very angry, and on top of his roof, which was higher than his neighbour's and not all that substantial, he balanced an enormous stone (big enough to fill a wagon) which threatened to fall at the least movement of the wall and wreck the man's roof, ceilings, floors, and looms. Terrified at the prospect the cloth-weaver ran to Sandro only to be told, in his own words, that in his own house Botticelli could and would do just what he wanted to. So there being nothing else for it the man was obliged to come to reasonable terms and make himself a good neighbour.

According to another anecdote, for a joke Sandro once denounced one of his friends to the vicar as a heretic. The man appeared and demanded to know who had accused him and of what. When he was told that his accuser was Sandro, who had alleged that he believed with the Epicureans that the soul dies with the body, he demanded to see him before the judge. And when Sandro appeared on the scene, he said:

"Certainly that is what I believe as far as this man is concerned, seeing that he's a brute. But apart from that, isn't it he who is the heretic, since although he scarcely knows how to read and write he did a commentary on Dante and took his name in vain?"

It is also said of Sandro that he was extraordinarily fond of any serious student of painting, and that he earned a great deal of money but wasted it all through carelessness and lack of management. Anyhow, after he had grown old and useless, unable to stand upright and moving about with the help of crutches, he died, ill and decrepit, at the age of seventy-eight, and he was buried in Ognissanti in Florence.[2]

In Duke Cosimo's wardrobe there are two very beautiful female heads in profile by Botticelli, one of which is said to be a mistress of Lorenzo's brother, Giuliano de' Medici, and the other, Madonna Lucrezia de' Tornabuoni, Lorenzo's wife. In the same place there is a Bacchus of Sandro's, a very graceful figure shown raising a cask with both hands and putting it to its lips. In the Duomo at Pisa, in the chapel of the Impagliata, he started an Assumption with a choir of angels, but it displeased him and he left it unfinished. In San Francesco at Montevarchi he did the panel for the high altar, and he also did two angels for the parish church at Empoli, on the same side as Rossillino's St Sebastian.

Botticelli was one of the first to find out how much to make standards and other draperies by plaiting the material so that the colours show on both sides without running. That was how he made the baldachin of

Orsanmichele, full of Madonnas, all different and beautiful. It is clear that this method of treating the cloth preserves the work better than the use of acids, which eat the material away, even though because of its relative cheapness the latter is nowadays the more usual technique.

Sandro was an uncommonly good draughtsman and, in consequence, for some time after his death artists used to search out his drawings, and I have some of them in my book which show great skills and judgement. In the scenes he did he made a lavish use of figures, as can be seen in the decorative work he designed for the frieze of the processional cross of the friars of Santa Maria Novella.

Altogether, Sandro Botticelli's pictures merited the highest praise; he threw himself into his work with diligence and enthusiasm, as can be seen in the Adoration of the Magi in Santa Maria Novella, which I described earlier and which is a marvellous painting. Also very fine is the small circular picture by Sandro that can be seen in the prior's room in the Angeli at Florence, the figures being tiny but very graceful and beautifully composed. A Florentine gentleman, Fabio Segni, has in his possession a painting of the same size as the panel picture of the Magi; the subject is Apelles' Calumny. He himself gave this unimaginably beautiful painting to his close friend, Antonio Segni, and underneath it can be read the lines by Fabio:

Iudicio quemquam ne falso laedere tentent
Terrarum reges, parva tabella monet.
Huic similem Aegypti regi donavit Apelles;
Rex fuit et dignus munere, munus eo.

This little picture warns the rulers of the earth
To shun the tyranny of judgement false.
Apelles gave its like to Egypt's king; that king
Was worthy of the gift, and it of him.

The following passages are taken from Cennino Cennini's Book of the Art, *in which the Tuscan painter expounds on the technique of art.*

HOW SOME TAKE UP PAINTING FROM AN INNATE REFINEMENT AND OTHERS FOR PROFIT
It is the impulse of their refined dispositions that induces some young men to engage in this art, for which they feel a natural love. Their intellects enjoy drawing merely because their own nature, of its own accord, attracts them to it, without any master's guidance, from an innate refinement. And prompted by this enjoyment, they next resolve to get a master; and they agree to stay with him, with love of obedience, submitting to serve him in order to attain perfection in the art.
There are others who take up painting from poverty and the necessity of earning a living, combining the desire for profit with a sincere love of our art. But above all these, they are to be commended who come to our art through a spontaneous love of it and an innate refinement.

WHICH ARE THE CHIEF VIRTUES THAT A MAN TAKING UP PAINTING SHOULD BE EQUIPPED WITH
Therefore, you who love this accomplishment because of a refined disposition, which is the chief reason for your engaging in our art, begin by adorning yourselves with these vestments: love, fear of God, obedience, and perseverance. And put yourselves under the guidance of a master as early as possible. And leave the master as late as possible.

HOW YOU SHOULD ENDEAVOR TO COPY AND DRAW AFTER AS FEW MASTERS AS POSSIBLE
When you have practiced drawing for a while as I have told you above, that is, on small panels, take pains and pleasure in constantly copying the best works that you can find done by the hand of great masters [...]. And as you go on from day

to day, it will be unnatural if you fail to pick up something of his style and of his mien. For if you set out to copy after one master today and after another one tomorrow, you will not acquire the style of either one or the other, and you will inevitably become fantastic, because each style will fatigue your mind [...]. If you imitate the forms of a single artist through constant practice, your intelligence would have to be crude indeed for you not to get some nourishment from them. Then you will find, if nature has granted you any imagination at all, that you will eventually acquire a style individual to yourself, and it cannot help being good; because your hand and your mind, being always accustomed to gathering flowers, would ill know how to pluck thorns.

HOW, BEYOND MASTERS, YOU SHOULD
CONSTANTLY COPY FROM NATURE WITH
STEADY PRACTICE
Mind you, the most perfect steersman that you can have, and the best helm, lie in the triumphal gateway of copying from nature. And this outdoes all other models; and always rely on this with a stout heart, especially as you begin to gain some understanding of draftsmanship. Do not fail, as you go on, to draw something every day, for no matter how little it is it will be well worth while, and it will do you a world of good.

HOW YOU SHOULD REGULATE YOUR LIFE
Your life should always be arranged just as if you were studying theology, or philosophy, or other sciences, that is to say, eating and drinking moderately, at least twice a day, electing light and wholesome dishes and thin wines; saving and sparing your hand, preserving it from such strains as heaving stones, crowbars, and many other things which are bad for your hand, from giving them a chance to weary it. There is another cause which, if you indulge it, can make

your hand so unsteady that it will waver more, and flutter far more, than leaves do in the wind, and this is indulging too much in the company of women.

ON THE NATURE OF ULTRAMARINE BLUE
Ultramarine blue is a noble, beautiful colour, perfect beyond any other; one could not say anything about it, or do anything with it, that its quality would not still surpass. And, because of its excellence, I want to discuss it at length, and to show you in detail how it is made. And pay close attention to this, for you will gain great honor and profit from it. And let some of that colour, combined with gold, which will grace any work of art, whether on wall or on panel shine forth in every picture.

THE PROPORTIONS WHICH A PERFECTLY FORMED
MAN'S BODY SHOULD POSSESS
Take note that, before you go any further, I will give you the exact proportions of a man. Those of a woman I shall omit, as they are not exact multiples of one another. First, as I have said above, the face is divided into three parts, namely: the forehead, one; the nose, another; and from the nose to the chin, another. From the side of the nose through the whole length of the eye, one of these measures. From the end of the eye up to the ear, one of these measures. From one ear to the other, a face lengthwise, one face.

From the chin under the jaw to the base of the throat, one of the three measures. The throat, one measure long. From the pit of the throat to the top of the shoulder, one face; and so for the other shoulder. From the shoulder to the elbow, one face. From the elbow to the joint of the hand, one face and one of the three measures. The whole hand, lengthwise, one face. From the pit of the throat to that of the chest, or stomach, on efface. From the stomach to the navel, one face. From the navel to the thigh joint, one face.

From the thigh to the knee, two faces. From the knee to the heel of the leg, two faces. From the heel to the sole of the foot, one of the three measures. The foot, one face long.

A man is as long as his arms crosswise. The arms, including the hands, reach to the middle of the thigh. The whole man is eight breast rib less than a woman, on the left side […]. The handsome man must be swarthy, the woman fair, etc. I will not tell you about the irrational animals, because I have never learned any of their measurements. Copy them and draw as much as you can from nature, and you will achieve a good style in this respect.

[1] *Decameron*, 5th day, novella.
[2] Botticelli died in 1510, aged sixty-five.